*Cover:*
**The Kiss,**
*1886, bronze, 5,91 x 3,62 x 3,79 m,*
*Jardin des Tuileries, Paris.*

*Graphic designer:* Sandrine Roux/Caroline Keppy
*Copy editor:* Christine Robert

Publication number: 330
ISBN: 2-87939-318-3
Printed in France.

JARRASSE, Dominique

Rodin

DOMINIQUE JARASSÉ

# RODIN

TERRAIL

6

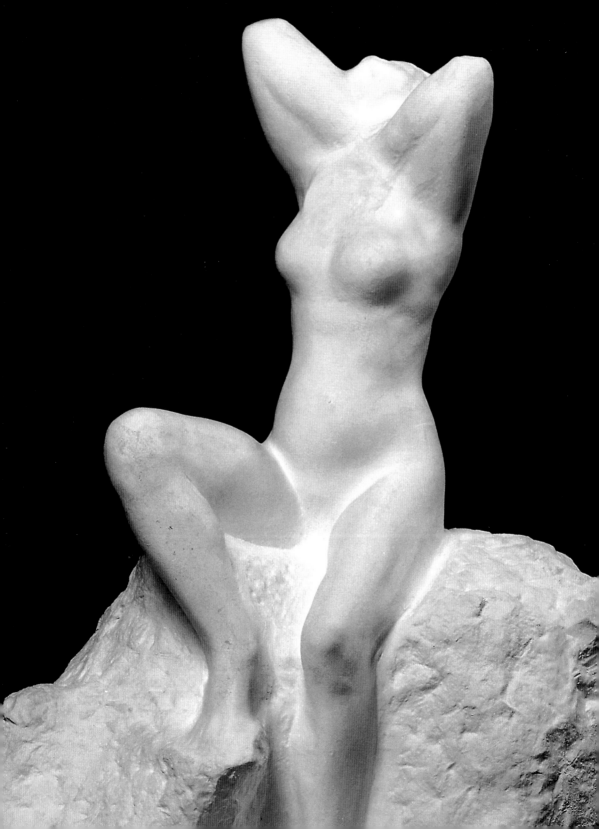

# introduction

The Awakening
*Plaster, 0.64 x 0.395 x 0.342 m.,*
*Paris, Musée Rodin.*

Rodin was obsessed with movement. His *Saint John the Baptist* and *Burghers of Calais* both present the quintessence of men in motion. Gorged with power, his *Balzac* seems to be on the verge of stepping forward, and one could say of him what the artist himself wrote of the figure of Eustache de Saint-Pierre, one of the *Burghers*: "He stands still, but he is about to walk ... This is something I gave a good deal of thought to... Movement, I long thought that it was everything, that it was the greatest of means. But statues do not move. One must feel that they can move."

In his 1846 and 1859 *Salons*, Baudelaire commented on the paralysis of sculpture in the nineteenth century. The craze for statuary had overloaded an architecture that had fallen prey to a horror vacui and had provided sculptors with a living, but was slowly contributing to the death of sculpture. A few artists like Rude and Carpeaux were able to avoid this fate, but only with Rodin was sculpture restored to its true importance and set on the course of modernity. Rejecting the copy and formula, his efforts achieved much more than combining the expressivity of move-

ment with an emphasis on form and the inherent qualities of the medium: through works that have taken on a quasi-mythical dimension, he initiated a revival of the true means and meaning of sculpture.

Rodin effected at one and the same time a synthesis of the great epochs of sculpture and inaugurated new techniques of composition and expression. Thanks to his mastery of the art of modelling, he enabled the body to express the intensity of its passions through its own forms. A fragment or a sketch from his hands could hold more meaning, more feeling, more art than any of the allegorical groups that were so much in vogue among his contemporaries. More than that, Rodin was involved in the unending process of the work-in-progress, and was thus one of the great precursors of modern creativity.

And yet there is something abusive in reducing Rodin to the rank of a precursor. He participated fully in the various aesthetic currents of his time: his work was a product of Romanticism, but it also had affinities with Symbolism and what came to be called Expressionism.

The side-by-side exhibition of his model for *Balzac* and *The Kiss* at the Salon of 1898 perfectly illustrated the various facets of Rodin's art. The same crowds who jeered sarcastically about the statue of the novelist, were able to forget its erstwhile objections to the subject-matter and suddenly had nothing but praise for the embracing couple. After the storms over *Hernani* and *Olympia*, Rodin's *Balzac* provided the nineteenth-century public with an opportunity to indulge in a last battle. Whereas The *Kiss* appealed to art-lovers because of its subject, its lifelike handling, and the high polish of the marble, the *Balzac* shocked them because of its coarseness and rejection of naturalism.

Yet this was no facile confrontation between tradition and the avantgarde: these two masterpieces were the work of one and the same hand. And, although we might be inclined to favour the innovative impulse today, we must reckon with the wide range of Rodin's genius and be prepared to alter our points of view accordingly.

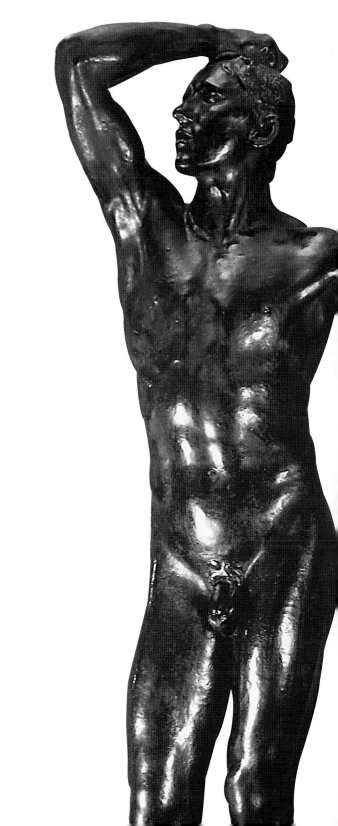

# The Burghers

## of Calais

The official inauguration of Auguste Rodin's *Burghers of Calais* was held on Sunday, 3 June 1895, in the Place Richelieu and in the presence of the artist and municipal authorities. The festivities were lavish with music, torchlight, cavalry parade, public dances and banquets. The monument had been commissioned by the municipality of Calais eleven years earlier, and, on that day, the 2,200 kilogram masterpiece by the greatest sculptor of the age exerted its full weight on the scales of history. For once, it came to pass that an official commission revealed itself as a significant, independent, and revolutionary work.

# A national imagery

The group, consisting of six larger-than-life bronze figures, depicted one of the most courageous deeds in French history: the surrender of the city keys to Edward III in order to end the eleven-month siege that had reduced the population to famine. This took place during the Hundred Years War, on August 3, 1347, one year after the decisive English victory at Crécy. Calais, extenuated by the siege, had no other choice but to capitulate. The conditions of the surrender were recorded in Froissart's *Chroniques*: the English King ordered that "six of the most eminent burghers, barefoot and with a rope around the neck, surrender the keys of the city and castle with their own hands", adding, "with them, I shall do as I please".

Froissart goes on to describe the heroic sacrifice of Eustache de Saint-Pierre, the richest burgher of Calais, followed by Jean d'Aire, Jacques de Wissant and his brother Pierre, then Jean de Fiennes and

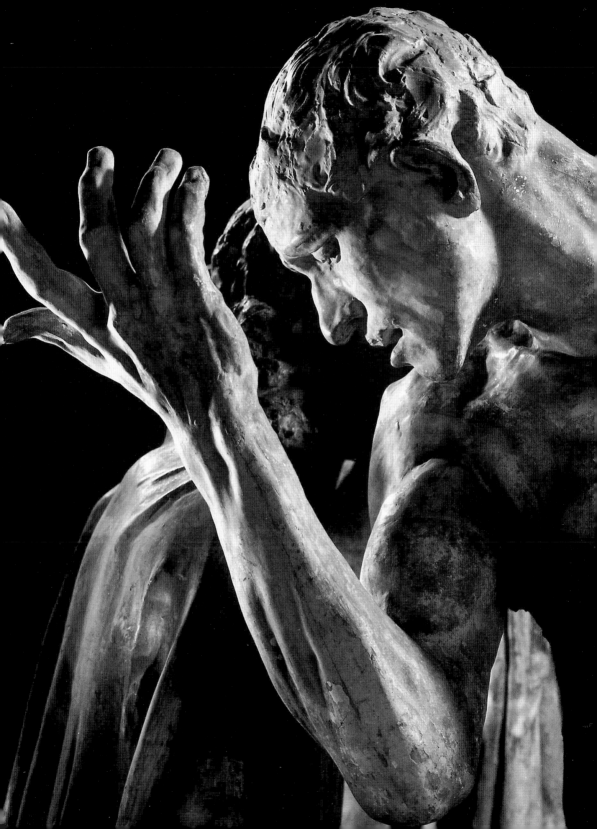

Andrieus d'Andres. Bearing the keys, unshod, dressed only in shirts and with a rope tied around their necks, they set out from the marketplace amid the lamentations of the populace for which they had accepted to die. The story, however, has a happy ending: the pregnant Queen, Phillipa de Hainaut, implored her husband to have mercy on the six courageous men – and obtained it. But, as they were making their way towards the English camp, they thought that these steps would be their last.

The most conspicuous figure in this huge sculpture is that of Eustache de Saint-Pierre. He advances deliberately, his venerable head bowed, his eyes half-closed; if he seems to vacillate, it is not because he fears death, but because of the privations he has had to endure. Jean d'Aire, on his left, displays no less valour. Holding the keys of the city which he must surrender to the English King, his body stiffens to face this humiliation.

Behind them, though, Andrieus d'Andres gives vent to great despair, clasping his hands to his head.

Jacques de Wissant, to the right, advances almost too hastily, as if he wanted to face his martyrdom and be done with it. Meanwhile, his brother, Pierre, makes a gesture as if trying to dispel a horrific nightmare, and Jean de Fiennes, the youngest member of this hapless group, appears hesitant to follow.

The exemplary character of this exaltation of the heroism of simple burghers need not be stressed. In a republican age, Calais had a moral obligation to commemorate it. The subject-matter was ready-made; all it needed was an artistic genius to do it justice.

Rodin took the full measure of the event from the start. He rejected the idea of a lone figure – Eustache de Saint-Pierre – and proposed a group. In this way he could depict the several facets of this exemplum virtutis and take a radical step away from conventional statuary.

Of no less importance was the moment that was being represented. Rodin chose the moment when the six notables were making ready to leave the city and obey Edward's summons; hence the impression of

movement, of getting underway. He deepened the symbolism by referring to the art of the fourteenth century, drawing on the sources of a national art for the sake of its evolution. This approach was all the more appropriate in the case of a patriotic monument, as the artist pointed out: "Our sculpture must be handled in the national style, that of the sublime Gothic age." Underscoring the fitness of the subject and a handling in the Gothic mode, he added: "This is why I chose to express my sculpture in the idiom of Froissart's time."

This medieval inspiration is confirmed by his allusion to "church tombs". One thinks of Claus Sluter, "maker of ymages", and his Moses Pulpit in the Charterhouse of Champmol: by their dignified and contained demeanour, his prophets and mourners are distant relatives of the *Burghers*. There is, however, a fairly clear difference in treatment to be noted: with Sluter, the drapery plays a key role in characterizing the figures, while Rodin resorted instead to more dramatic gestures, with a more complex composition and modelling.

# The search for expression

Following pages :
**The Burghers of Calais**
*Bronze, 2.31 x 2.45 x 2.03 m.,*
*Paris, Musée Rodin.*

Commissioned in 1884, but unveiled only in 1895, this monument was the first instance of an official memorial treated without recourse to convention. It displays an independence and expressivity never before seen in this context.

With his first model, submitted in November 1884, Rodin had established a cubic volume for the composition, in order to underscore, in formal terms, the equality of the burghers. This effect was reinforced by the great classical pedestal that he had also designed. The six figures, arm in arm, reduced to the same condition by their ropes and clothing, form a compact group, with the heads projecting haphazardly; only the outstretched arm of Eustache de Saint-Pierre stands out. Still, each figure is personalized and expresses a particular aspect of the drama. After movement, Rodin searched for expression in this group, and through sketches, models and fragments, he worked out the variations over the years.

This first plaster model, although avoiding the traditional pyramidal format for singling out a hero, was enthusiastically received by the Calais town fathers, and the commission was made official on January 13, 1885. Rodin made the journey to Calais on July 26 to present his new model personally, but it was not so unanimously admired. Yet most of the poses had been established: Eustache de Saint-Pierre remained the focus of the composition, with the other figures seeming to turn around him; they display a variety of facial expressions and body positions in a handling that

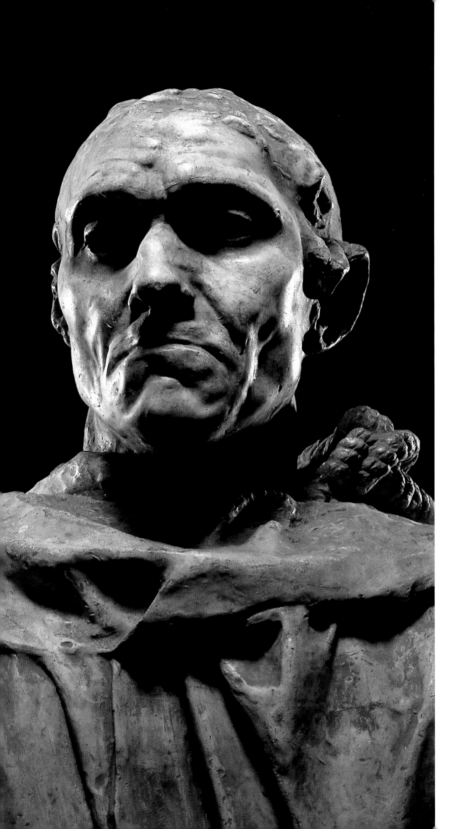

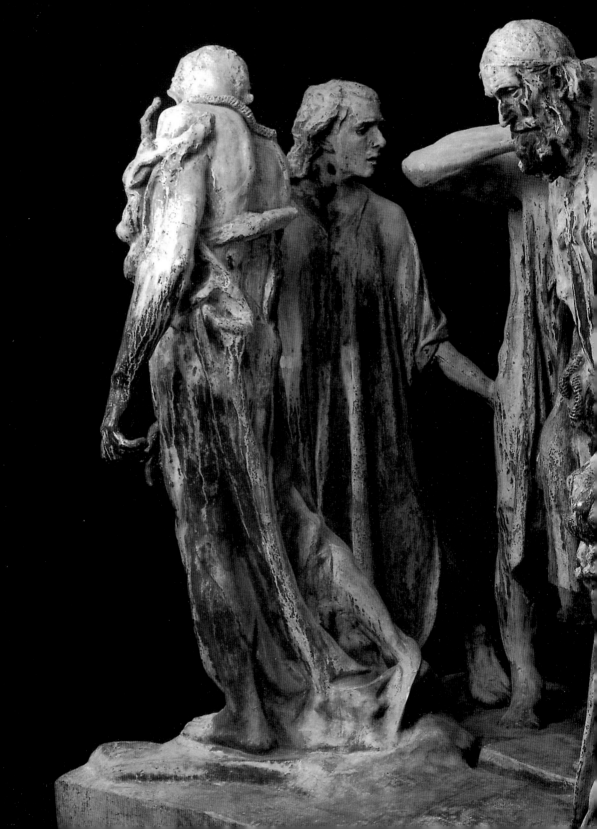

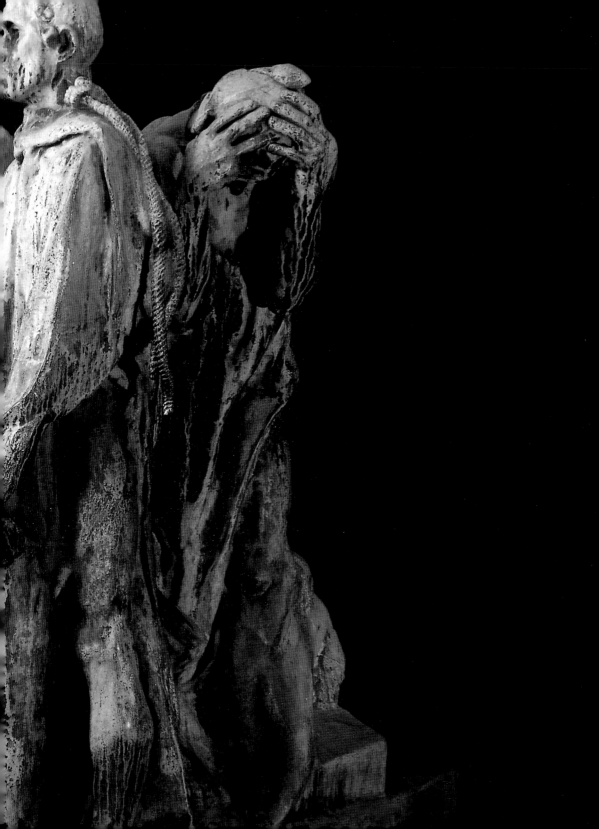

recalls the rotational effect achieved by Carpeaux (1827-75) in his *Dance* on the façade of the Paris Opera and in his fountain at the Observatory (1874).

The basic principles of the monument – a "cubic" volume and contained movement – had been laid down. All that remained was to find a fitting characterization for the individual figures.

"I came gradually to the idea that sculptural expression is the essence of the art of statuary – expression through modelling", Rodin explained in a letter to Frederick Lawton, an Englishman living in Paris who devoted two publications to him in 1906 and 1907. After his first two models and the ensuing confrontation with his clients, Rodin, feeling less fettered, embarked on an extraordinarily fertile campaign of work. He turned out scores of contour sketches, nudes, fragments of bodies, heads and hands, which became works in their own right or were incorporated into other contexts. The heads were treated with a nervous and brisk modelling. Every facial feature was stressed, the wrinkles, dimples, bone structures, turning each of the faces into a world of reliefs in which there was not an inch of space that had not been fashioned and marked by the sculptor's hands. The face of Pierre de Wissant, with his recessed and half-closed eyes, parted lips, his soul revealed in the corners of the mouth, expresses extreme pain being withheld. It was such a successful piece that it was cast separately and even issued in a colossal version (80 cm high). Like the head of Jean de Fiennes, it would be used in other assemblages, with a female body, with hands, and so on.

With Rodin, a hand could express the most diverse emotions. All by itself, it could express the pathos of an entire figure; hence his frequent recourse to the fragmentary. The hands implore, suffer, give, withhold, and so on. Hands were Rodin's passion, and modelled by him they became the outlets for an astonishing variety of expression; mounted on a base, they became works in themselves. Very likely the hands of the *Burghers* were the source for the *Hands of God* and for *The Cathedral*, executed a quarter of a century later.

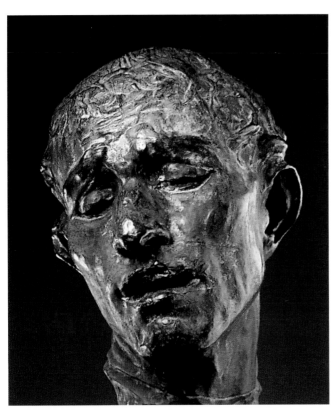

**The Burghers of Calais**
Colossal Head of Pierre de Wissant
*Bronze, 0.81 x 0.40 x 0.54 m.,*
*Paris, Musée Rodin.*

This is one of the heads in which the
sculptor best rendered the pathos
of these men's self-sacrifice.

**The Burghers of Calais**
*First model, 1884, plaster, 0.61 x 0.38 x 0.312 m.,*
*Paris, Musée Rodin.*

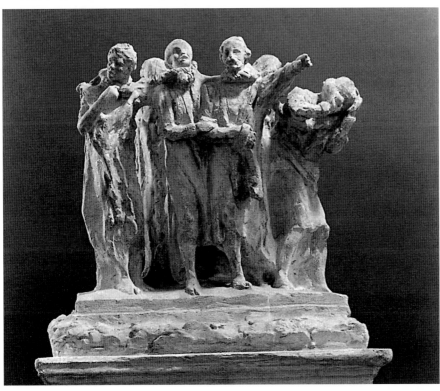

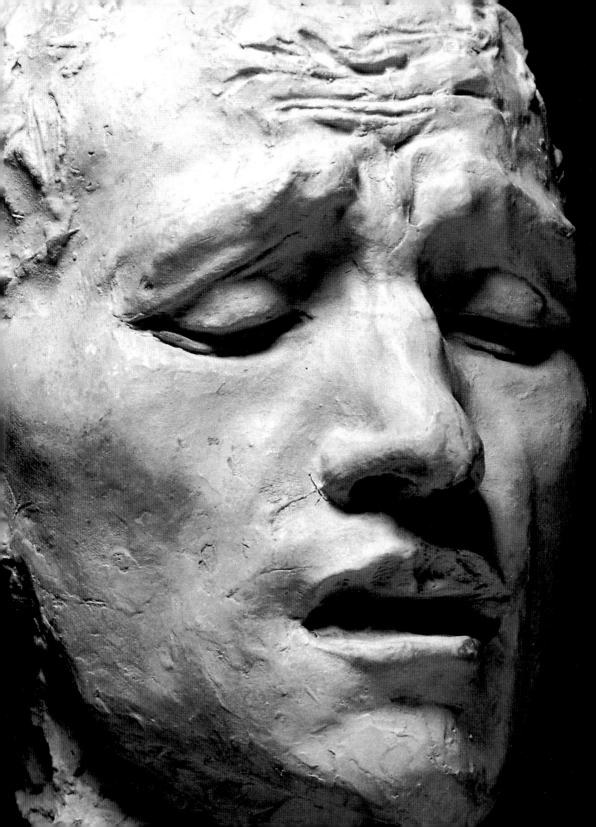

**The Burghers of Calais**
Head of Pierre de Wissant
*(called Type A) Terracotta, 0.286 x 0.20 x 0.22 m.,*
*Paris, Musée Rodin.*

In his unending search for motifs, Rodin often resorted to marcottage, that is, using already finished works as parts for new arrangements. He was quite fond of disassembling and recombining elements from different sculptures. The bust of Jean d'Aire, for example, was treated independently, like an austere antique portrait of Seneca; the hands of one of the Wissant brothers found their way into a composition with a head of Camille Claudel; the head of Jean d'Aire was also used to make those of Jacques de Wissant and Andrieus d'Andres. The *Burghers* and the *Gates of Hell* furnished him with the opportunity to develop this daring process of fragmentation, repetition, and assemblage into a veritable creative principle. This was not only a sign of great modernity, but it also expressed Rodin's refusal to be a slave to realism, in the sense of reproduction: so what if the portraits presented anomalies and if the limbs were disproportionate – this only made the figures that much more expressive!

During the years 1886-89, Rodin worked on the figures as nudes before finally draping them. The finished group was exhibited at the Georges Petit Gallery in 1889. The monument itself was not cast before 1895, however, because of intervening budgetary problems and the bankruptcy of the bank which had been entrusted with the subscriptions. Only in 1892, with the return to office of Mayor Omer Dewavrin, initiator of the commission eight years before, was the project finally brought to completion.

The definitive version of the monument emphasized the pathetic character of the six burghers, giving them individualized attitudes – if not always differentiated facial types – and attenuated the effect of certain gestures that had been deemed too grandiloquent. For the sake of greater simplification, accessories like the cushion with keys were left out; the clothing contributed to the formal integration of the figures, but the drapery was restrained.

The Austrian poet Rainer Maria Rilke (1875-1926), Rodin's secretary in 1902 and the author of a book on the sculptor, brilliantly formulated the deeper meaning of each of the figures, while casting the sculptor in the role of a demiurge:

"He created the old man with hanging arms, loosened in their joints, and gave him a heavy and dragging tread, the worn-out gait of old men, and an expression of fatigue which soaks his face down to his beard.

"He created the man carrying the key. He has life enough in him for many more years, but all of it compressed in his sudden final hour. This is hard for him to bear. His lips are shut tight, his hands are clamped on the key. He has ignited his strength and it consumes him from within, in his stubbornness.

"He created the man who holds his bowed head in his hands, as if withdrawing into himself, to be alone for one last time.

"He created the two brothers, one of whom looks back still, while the other hangs his head in a gesture

of resolve and submission, as if he already faced the executioner.

"And he created the vague gesture of this man who seems only 'to be passing through life'. Gustave Geffroy called him the 'passer-by'. He is on his way already, but he turns to look back one last time, not at the city, not at the mourners, nor at his companions. He turns to look at himself. He raises his right arm, bends it, hesitates..."

Rilke chose not to name these bronze figures, but to capture their universality instead. For, out of a commonplace programme and in an atrophied medium, Rodin had created a memorial in which human values were expressed with all their original power. These are men who are offering up their lives, who are suffering and facing the anguish of death, who, with an exemplary self-abnegation, are surrendering themselves, almost in spite of themselves, for their country. These are not idealized knights, but ordinary burghers who choose humanity over force, and whose courage is expressed in terms of suffering. Not surprisingly, the burghers of turn-of-the-century Calais, accustomed to allegories, did not immediately recognize the image of their heroic ancestors in these human, all-too-human, figures, these anti-heroes who would have been on the same footing as their descendants had Rodin's original instructions for installation been followed.

**The Burghers of Calais,**
Jean d'Aire,
*1889, plaster with wax and coating, 2.331 x 2.25 x 2.03 m., Paris, Musée Rodin.*

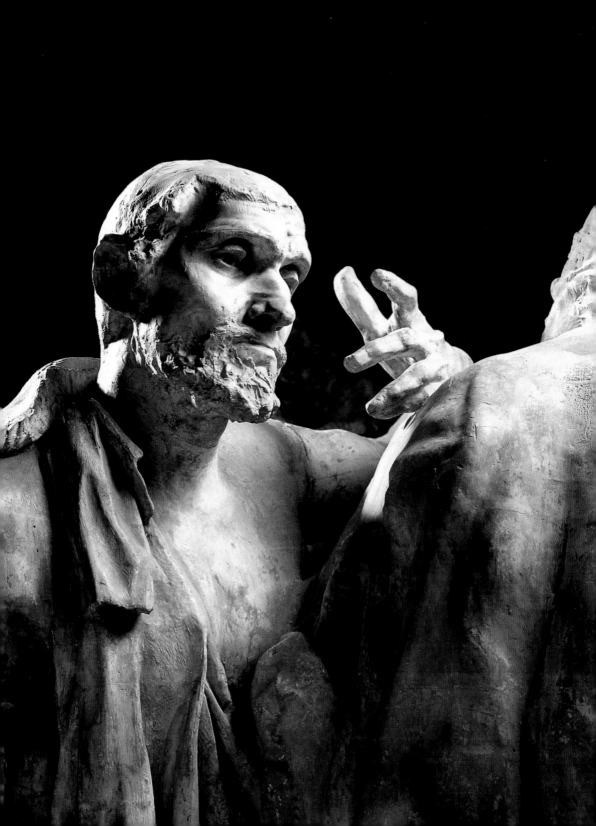

# The staging
## of the monument

Although the committee waved its objections to the composition of the group in 1885, its emplacement still provoked a lot of discussion. At stake in this debate on where and how the monument was to be displayed, was the issue of monumental sculpture itself. Opinions swung between an accentuation of the group's heroic nature and a sort of down-to-earth humanization. At the heart of the difference of opinion that opposed Rodin and the authorities of Calais was the question of the relation of sculpture to public space, an eminently modern concern.

The 1884 model idealized the group through the device of a pedestal that presented, as Rodin himself explained, "the rudiments of an arch of triumph, intended to uphold, not a quadriga, but human patriotism, self-abnegation and virtue". It was a conventional mise-en scène. Similarly, the proportions – those given to the burghers by the artist, and those stipulated by the contract, which called for figures at least two metres high – contributed to an impression of super-humanity which was completely in line with the committee's wishes. But it was not long before Rodin began to seek

**The Burghers of Calais**
*Tentative disposition on a raised platform
at Meudon. Photographer unknown.
Paris, Musée Rodin.*

The order for a replica of the monument for London provided an opportunity to experiment with a raised installation set against the sky.

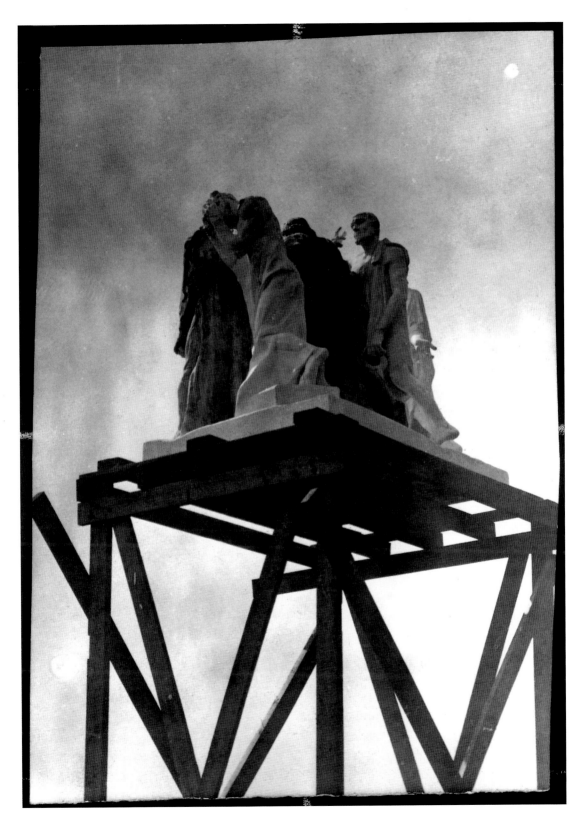

**The Burghers of Calais,**
Hands of Eustache de Saint-Pierre,
*Plaster, 0.26 x 0.118 x 0.11 m.,*
*Paris, Musée Rodin.*

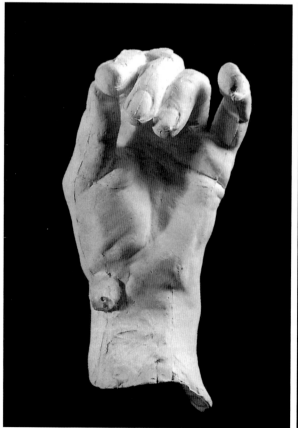 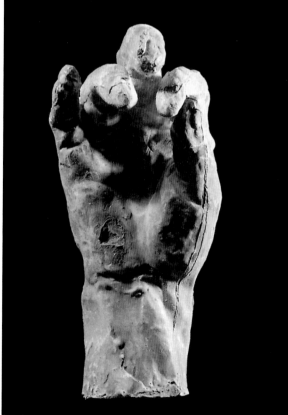

instead to bring the heroes closer to their fellows by installing the sculpture in the middle of a square.

In 1893, he was still hesitating between a low placement and a raised pedestal that would have set the monument against the sky and facing the sea, as Rilke reported. He seems nonetheless to have favoured the down-to-earth solution so that the group would become "more familiar" and permit "the public a more direct access to the drama and tragedy of this sacrifice", to "let the spectators penetrate to the crux of the subject, as in the church tombs". Contrary to the classical monument, which set the hero in an ideal space, the medieval reference justified a low placement and replacing the pyramidal format with a cube.

The municipal authorities, however, insisted upon a base, a sort of neo-Gothic altar, and an enclosure designed by the municipal architect Decroix. Rodin seemed to be going along with this; yet, in his conversations with Paul Gsell in 1908, he recalled:

"You have observed quite rightly that my burghers are arranged according to their degree of valour. As you know, to emphasize this effect, I wanted to set my statues in a line at ground level right in front of the Calais Town Hall, like the beads in a rosary of suffering and sacrifice. My figures would thus have seemed to be heading from the Town Hall to the camp of Edward III. And the citizens of Calais today, almost rubbing elbows with them, so to speak, would have felt the traditional bond of solidarity that ties them to these heroes."

As a last modification, the group was finally transferred to the Place d'Armes – without a pedestal – in 1924. It took a generation for the sculptor's intention to be finally understood. *The Burghers of Calais* might have been just another textbook example of monumental sculpture, but, thanks to the sculptor's powerful modernity, it became part of the cultural heritage of the world: copies of it may be seen in Copenhagen, Brussels, London, Basel, Philadelphia, Washington, Los Angeles, and Tokyo.

**The Burghers of Calais,**
*Bronze, 2.331 x 2.45 x 2.03 m.,*
*Paris, Musée Rodin.*

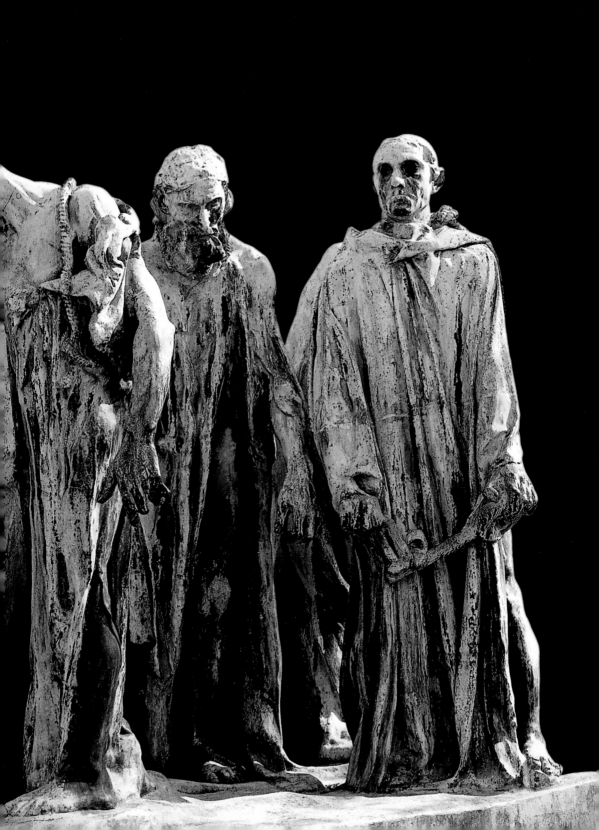

# Forty years
# of oblivion

Rodin was forty years old when he was commissioned to make a door for the future Musée des Arts Décoratifs in 1880. This project, and the monument for the *Burghers of Calais* in 1884, brought him out of obscurity and into the spotlight. After many years of effort and struggle, Rodin suddenly emerged as a master, sure of his means and of himself. While other sculptors had gained approval through teaching, the prize system and showings at the Salon, Rodin had had to learn and make himself known almost entirely on his own. This was not such a bad thing, however, for, with the academic system in full decay, he appeared as one of the few artists able to breathe new life into his medium. Already in 1864, the young Rodin, who had been rejected by the École des Beaux-Arts, made a try at official recognition and gaining admittance to the commissions network by exhibiting a work at the Salon. After the Salon des Refusés of 1863, what could he not hope for? In the eyes of posterity, with his *Man with the Broken Nose*, Rodin shares the glory of Manet and his rejected *Déjeuner sur l'herbe* of the previous year. But at the time this rejection was a harsh verdict, for it meant being relegated to the limbo of artists unfortunate enough not to have received the École des Beaux-Arts' seal of approval. More concretely, for the impoverished artist, this meant having to make ends meet by any and all means. This difficult period, which ultimately had a salutary effect on his stylistic development, was to last until 1880. A number of handicaps may have contributed to Rodin's difficulties, and foremost among these was his refusal to adopt the conventions of his day.

# A trying childhood

Rodin was born in Paris on November 12, 1840, in the popular Mouffetard quarter at 3, rue de l'Arbalète. His mother was from Lorraine, and his father, Jean-Baptiste Rodin (1802-83), was a civil servant at the Préfecture who, by the end of his career, was an inspector. His modest and religious background did not favour the kind of connexions that facilitated access to the key institutions. Rodin was educated at the neighbourhood school and in Beauvais, but throughout his life

**Portrait of Father Eymard**

*1863, bronze, 0.14 x 0.10 x 0.12 m.,*
*Paris, Musée Rodin.*

38

**Portrait of Jules Dalou, Sculptor**
*1882, bronze, 0.52 x 0.425 x 0.22 m.,*
*Paris, Musée Rodin.*

he was to suffer from his cultural insufficiency, which was exacerbated by the nearsightedness that had hindered his schooling.

When he realized that he wanted to become an artist, he persuaded his parents to send him to the imperial drawing school, then known as the "Petite École" (as against the École des Beaux-Arts), which later became the École des Arts Décoratifs. This establishment was supposed to train craftsmen and artisans for the applied arts. It was a legacy of the eighteenth century, and had preserved its spirit, which naturally influenced Rodin. As a "commoner", Rodin had no chance of entering the École des Beaux-Arts directly, but the Petite École had had its stars, like Carpeaux, and was a good starting point. Rodin had the opportunity to study with Lecoq de Boisbaudran (1802-97), whose method, outlined in *Éducation de la mémoire pittoresque* (1847), consisted in getting students into the habit of drawing from memory. He also proposed a variety of exercises that broke off from conventional practice; Fantin-Latour recalled that he had even conducted a class outdoors. Rodin owed a lot to the drawing techniques he learned from Lecoq, and

expressed his gratitude in a letter-preface to a new edition of the master's writings in 1913. The Petite École, however, limited the artistic ambitions of its students; drawings were done from plasters, and the training was oriented towards practical professions, like handcrafter, decorator or draughtsman, the path taken by Rodin's cousin and fellow-student Émile Cheffer.

With a good school record and a First Prize in modelling, Rodin had reasonable chances for being admitted to the École des Beaux-Arts; yet he was rejected three years in a row (1857, 1858, 1859). Thus began particularly hard times for the young Rodin, who had to work for other decorators. In one firm, he met Jules Dalou, a former student of the Petite École who had been admitted to the École des Beaux-Arts and who, apart from being his friend and rival, became one of the leading sculptors of the late nineteenth century. Around this time too, his elder sister Marie, after a disappointing love affair with his friend, the painter Arthur Barnouvin, withdrew into a Ursuline convent and died at the age of 24. Deeply affected, Rodin himself withdrew into a monastery of the Order of the Holy-Sacrament.

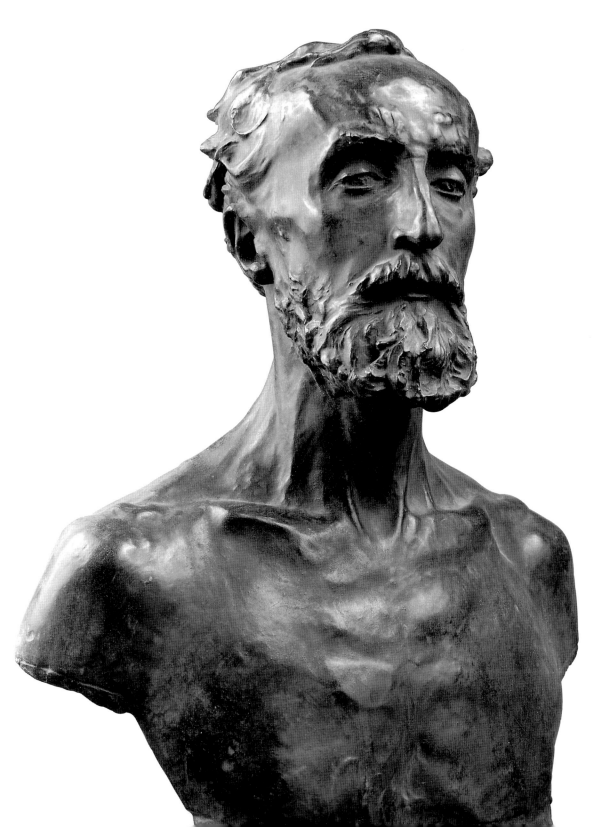

Rodin was nevertheless determined to become a sculptor. As he later reminisced, "I made separate pieces – arms. heads, and feet – then I took on the whole figure. I could grasp the whole at a glance. I did this with as much ease as today. I was ecstatic." Allowance being made for the inevitable bias in memories expected to coincide with the artist's image, these words display the unswerving will which gave him the courage to continue learning, all the while working at a full-time job. Thus he attended evening courses at the Gobelins, history courses at the Collège de France, and assiduously visited museums, print collections and libraries. While at the Petite École, he had been able to attend Barye's lectures at the Natural History Museum, but he had not appreciated the value of this modest yet much-criticized sculptor. He was to regret this, for Barye, an animal sculptor, was one of the few artists of his time who successfully resisted the influence of academicism and achieved a personal mode of expression which combined realism with a romantic tension.

The inner necessity which drove Rodin was something that Father Pierre-Julien Eymard, whose community he joined in 1862, could understand: he let him set up a workshop in the courtyard of the monastery, and even posed for a portrait-bust. The result was not to his liking, but it remains as an important example of Rodin's early efforts. He vigorously rendered the clergyman's stern and fervent character, giving him a high-blown hairstyle which creates an overexalted and romantic – "diabolic" was the Father's word – image of him. Nor was his own father too pleased to see himself immortalized in the manner of a Roman emperor – shorn of beard and hair. Yet, here too, the precise modelling, the lifelike features of the austere face, and the classical simplicity, all attest to the mastery that Rodin had already achieved by the age of twenty-four.

When he left the monastery in 1864, Rodin went back to work and set up a studio in a former stable in the rue Lebrun. This step was an act of emancipation, not only from his family, but also from his work so far. In this studio he executed the first piece he deemed worthy of representing him at the Salon, *The Man with the Broken Nose*. He also worked with a young seam-

stress, Rose Beuret, and initiated a relationship that was to last until their deaths fifty-five years later. With Rose as model, he undertook a large free-standing figure, a *Bacchante*, which, to his lifelong regret, was lost during a move. These early works, like the model and the artist, had to withstand the same harsh conditions of a humid and poorly-heated studio. One of Rose's virtues, once she had settled for the role of servant-mistress, was to care for Rodin's clay sculptures by wrapping them in a wet cloth until funds could be found to have them cast.

Poor, unknown, and obliged to devote most of his days to producing ornamental designs, Rodin managed to develop an extraordinarily skilled hand which allowed him a great facility of execution. At the same time, he formulated his artistic principles, foremost of which was a distrust of the academic system that had rejected him. In his later years, he would give full vent to his hatred for the Institute, going so far as to congratulate himself for having been spared from a school that would surely have distorted his talent, as it had Dalou's. Rodin's biographer, Frédéric Grunfeld quotes this note of his: 'Rejected by the École des Beaux-Arts. Good fortune." This may have masked his rancour, but it is a fact that he developed his art completely in opposition to the official teaching. Nevertheless, thirsting for the recognition that had eluded him for so long, he did not disdain the honours when they finally began to pour in, far from it. His robe as Doctor *honoris causa* at the University of Oxford (1907) was a source of enduring satisfaction.

# A bust mutilated by misery: The Man with the Broken Nose

In this first major piece, chance – a dimension which Rodin integrated into the creative process, anticipating the artists of the twentieth century – played a role which demonstrated his misery, while it permitted him to create his first fragmentary work. The choice of model and the head's final appearance were the product of poverty. Rodin took as his model a poor soul named Bibi, who occasionally came to clean his studio. The deeply-etched, deformed face, with its broken nose, might seem hideous at first glance, but Rodin saw beyond this and brought out its beauty, as character and expression. And so he depicted him as he was, and with all the more fidelity as this was indirectly a link to Michelangelo, who also had a broken nose. At a time when he had probably not yet read Baudelaire, he was already applying principles which he formulated in this way in 1907: "Since it is the power of character which makes for beauty in Art, it often happens that the more ugly one is in Nature, the more beautiful one is in Art."

The old man's head was depicted in the antique manner, but with an accentuation of the features and a dissymmetry which make this a remarkable work for a "beginner". Finished in Winter, the bust was reduced to a mask when the back of the head was shattered by frost. However, this did not deter Rodin from submitting it to the Salon jury.

Given its coarse handling and its condition, the portrait-head of this un-known could only be rejected. As a result, Rodin withdrew into isolation and did not venture to exhibit anything in Paris for over a decade. Yet he was not one to give up or to abandon his own works: he made a plaster version of *The Man with the Broken Nose* to be shown in Brussels in 1872 and at the Salon in 1875, where he simply rechristened it *Portrait of Mr. B*. This last version, in marble, stressed the classical register by including a ribbon around Bibi's hair, in the manner of the Greek philosophers. For the Salon of 1878, Rodin executed a version in bronze. He was to produce more than ten variations on this first portrait-head, including in the *Gates of Hell* and in *The Sculptor and his Muse*.

**Man with the Broken Nose**
*1864, bronze, 0.26 x 0.10 x 0.23 m.,*
*Paris, Musée Rodin.*

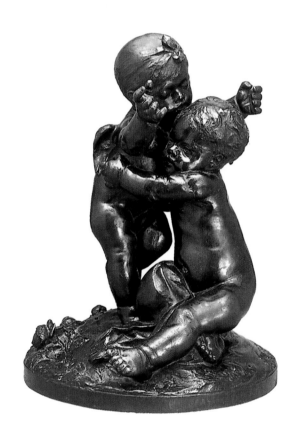

**The Idyll of Ixelles**
*1876, bronze,*
*0.525 x 0.408 x 0.415 m.,*
*Paris, Musée Rodin.*

In the meantime, Rodin continued to work on the side, becoming a father in January 1866, with the birth of a son, Auguste Beuret. Even so, he waited until the eve of her death, in 1917, before he finally married Rose. In 1864, he had entered the prestigious studio of the sculptor Carrier-Belleuse, another brilliant graduate of the Petite École, on whom the high society of the Second Empire showered commissions: decorative objects, clocks, statuettes, and more important groups for the Opera or the Louvre. Rodin assisted mostly with the busts, producing them in series of models to be produced in every imaginable form and size. This was a principle which he would retain and apply when he became the head of his own business concern. In this way he came to work on the decoration of a town-house owned by La Païva, a demi-mondaine, which became a showcase of Second Empire decorative fashions and luxury. Like a journeyman on his tour de France, Rodin had occasion to work in Marseilles and Strasbourg, where he was given the task of executing imitations of medieval sculptures. He returned to Carrier-Belleuse and followed him to Brussels after the War of 1870-71, when he was commissioned to decorate the Stock Exchange. When Van Rasbourg, one of Carrier's assistants, returned to France to take charge of his studio there, Rodin chose to stay in Brussels and continue working with him on projects like the Palais des Académies and the houses on Boulevard Anspach. At the same time he provided works in the eighteenth-century manner to be commercialized by the Compagnie des Bronzes: examples of this are a graceful *Suzon* and a group of putti, *The Idyll of Ixelles*.

His material situation having stabilized, Rose joined him in Belgium in 1872, and he was able to devote himself to his own work: he exhibited an Alsatian Girl in Ghent in 1871, and undertook ambitious projects. Ever fascinated by the human body, he worked on a large male nude as a pendant to his *Bacchante*.

# The Age
## of Bronze

**The Age of Bronze**
*1877, bronze, 1.80 x 0.80 x 0.60 m.,
Paris, Musée Rodin.*

This statue caused Rodin to be accused of making life
casts; only the State's purchase of the bronze in 1880
alleviated this suspicion somewhat.

In 1875, Rodin made a seminal journey, a veritable
initiation into a dimension of art which he had been lack-
ing: his travels took him to Italian cities like Florence,
Rome, and Naples, searching for traces of Antiquity and
Michelangelo. This precursor helped him to free himself
further from the prevailing academicism and intro-
duced him to bold poses which he found surprising at
first. In Naples, he took special notice of the *Doryphorus*
of Polykleitos, a famous marble in which the pose
(especially the legs) was very similar to a lifesize statue
that he had just begun, using a soldier, Auguste Neyt,
as model (originally, he held a spear). The Medici Tomb
at San Lorenzo made an especially lasting impression
on him: Rodin's *Thinker* has often been compared to the
statue of Lorenzo de Medici, which already in the six-
teenth century was known as *Il Pensieroso*.

Back in Brussels, Rodin returned to his male nude
and studied it with extreme care, analysing each contour,
working elaborately on the modelling of each part,
endowing the body as a whole with an energy and
dynamism which integrated the Antique in its con-
tained power and the example of Michelangelo in the
position of the limbs. The exact subject of this hand-
some, lifelike body was so secondary in comparison
that the title was changed to suit the occasion. When it

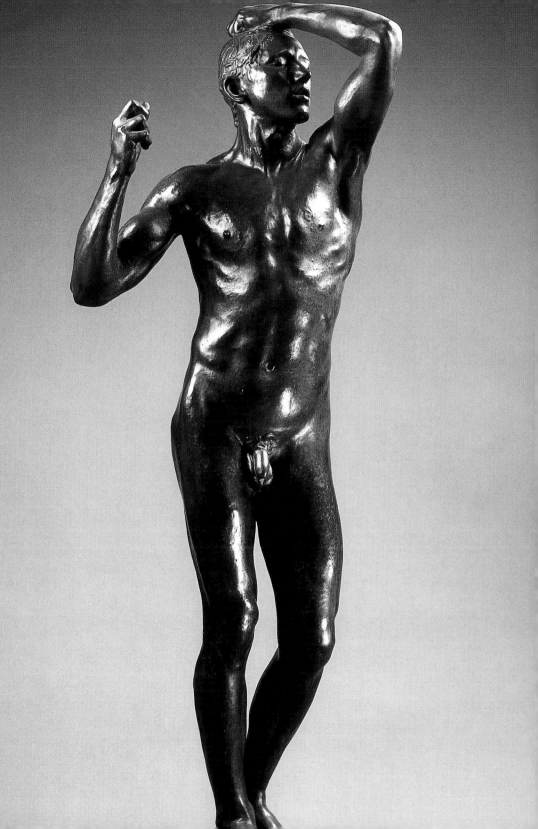

was presented in Brussels in 1877, it was called *The Vanquished*, an allusion to the French defeat. It also appeared with the title *Man Awakening to Nature*, and in a more Rousseau-like register, *Primitive Man*. It was described at the Salon of Spring 1877 as *The Age of Bronze*, a title which reflected the original purity and sense of awakening that characterize the work, while it corresponded to a vogue for prehistoric subject-matter. The title was of little concern to Rodin; what mattered the most to him was form in three-dimensional space and the representation of life.

His success with this piece was such that, on the occasion of its exhibition in Brussels, a critic coined a term that was to be on everyone's lips at the Salon in Paris: surmoulage, that is, a cast made directly from the model, and not a carved sculpture. Now this was the first ambitious work presented by Rodin. It was a crucial confrontation with the public. Sixteen years after the rejection of the *Man with the Broken Nose*, his *Age of Bronze* was accepted, but it unleashed a scandal that was to rankle him for the rest of his life. Even in his *Cathedrals of France*, published in 1914, we can find the following passage: "In the field of statuary, the making of casts from life, that canker of art, is flourishing." For the time being, though, the suspicion stuck, in spite of Rodin's objections and the testimony of his colleagues. Only in 1880 did the French State make up for this affront by commissioning a bronze of this piece, and granting him a third medal, later further confirmed by a gold medal in Ghent. While this episode

left him so impoverished that he had to return to Carrier-Belleuse, it had brought him to the attention of a number of his peers who sensed that he had the makings of a great master. *The Age of Bronze* marked the end of Rodin's sojourn in Belgium, which was part-exile and part-idyll shared with Rose, with whom he would explore the countryside, painting landscapes along the wayside. These years, and the wealth of experience which they brought, were formative for Rodin's mastery of a very personal art.

Having weathered this storm, and re-established in Paris, Rodin untiringly continued work on the personal projects that he had begun in Brussels – a seated *Ugolino* and a striding *Joshua* – all the while executing works to decorate the Trocadéro or for the Sèvres porcelain works, where Carrier-Belleuse had been appointed director of artistic projects. His participation in public contests had so far brought no results. His main concern, however, was to expose the injustice of the accusation of surmoulage. Consequently, he undertook a larger-thanlifesize figure of *Saint John the Baptist Preaching*, a piece which seems to have evolved out of his *Joshua*.

**Ugolin Seated**
*1876-7, plaster, 1.08 x 0.80 x 0.79 m., Paris, Musée Rodin.*

Worked out in Belgium, this *Ugolino*, which derived from the *Torso of Belvedere*, was a step towards *The Thinker*.

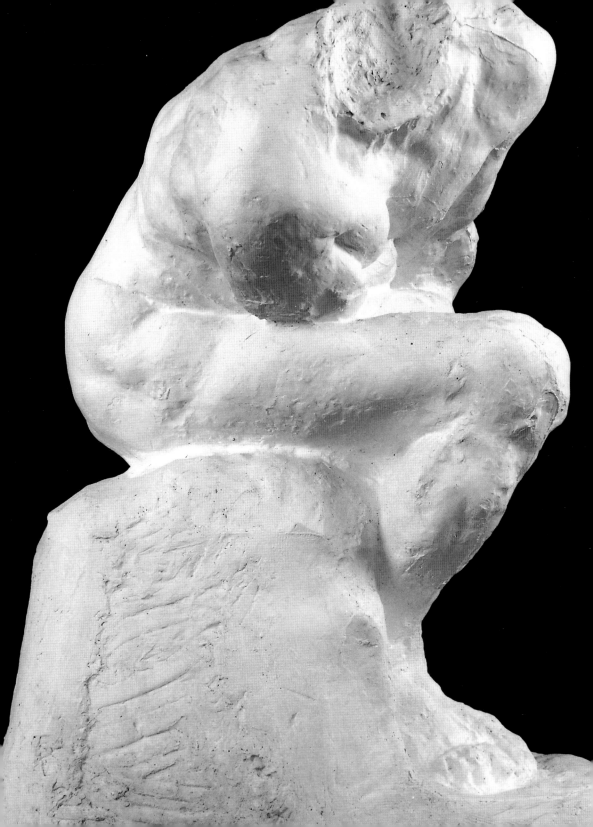

# Saint John the Baptist,
## a walking man

As model for his *Saint John the Baptist*, Rodin hired the services of a simple and robust Italian peasant with the name of Pignatelli. Movement and strength in this new free-standing sculpture are more accentuated than in *The Age of Bronze*. One should not lay too much stress on the traditional title and its religious reference; *Walking Man* would be more appropriate, for the study of the human form was Rodin's prime concern here. Sketches for the saint substantiate this: figures without heads or arms, heads alone, and other fragments bear witness to his constant search for the telling detail, the expressive part which evokes the life and character of the whole better than a finished work.

Marcelle Tirel, who worked as Rodin's secretary starting in 1906, gave an account of the genesis of *The Walking Man*, that is, a sketch or fragment of the *Saint John the Baptist* which he exhibited with this title in 1907. Irritated by critics who chided him for not finishing his statues, Rodin exclaimed: "I will never again make anything complete, I will make only antiques", and, walking past one of the casts of the *Saint John the Baptist* in his studio, he lopped off its head. This

**Head of St John the Baptist**
*1887, bronze, 0.114 x 0.268 x 0.205 m.,*
*Paris, Musée Rodin.*

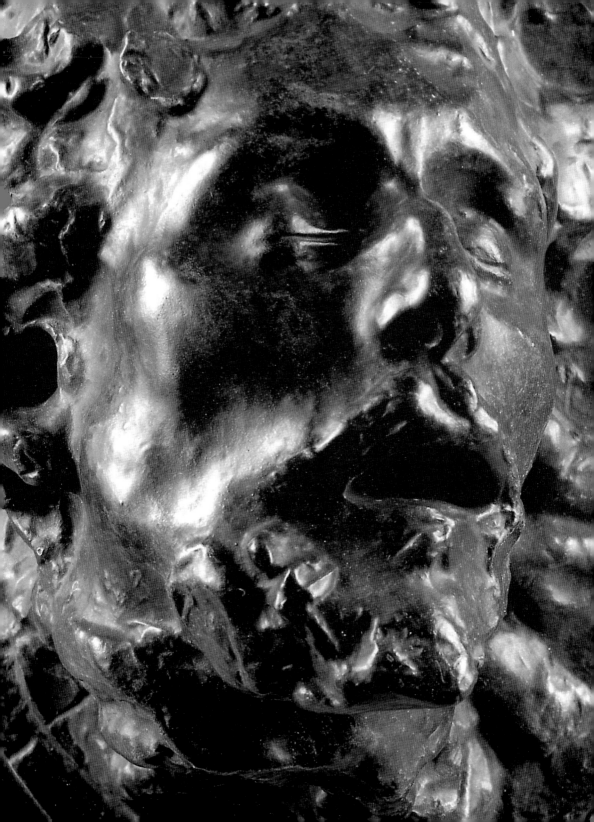

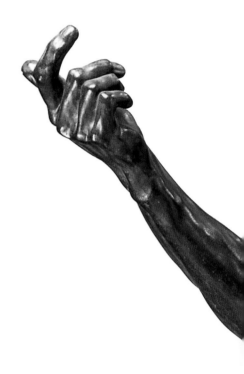

**Saint John the Baptist**
*1878, bronze,*
*2.003 x 0.725 x 1.105 m.,*
*Paris, Musée Rodin.*

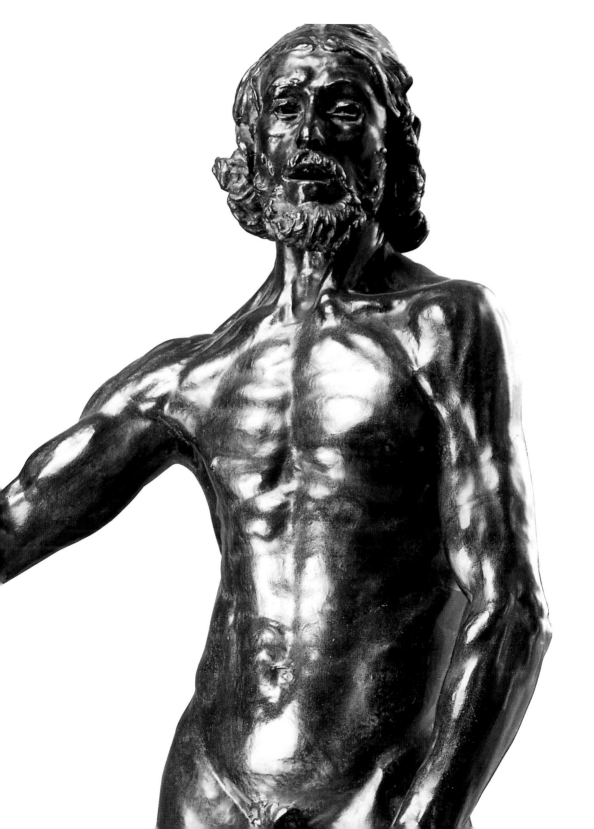

**Walking Man**
*1877–1911, bronze, 0.85 x 0.28 x 0.58 m.,*
*Paris, Musée Rodin.*

The Walking Man was developed out of St John
the Baptist; the mutilation eliminated the anecdotal
features and accentuated the movement.

was supposedly the birth of *The Walking Man*. The anecdotal interest aside, this story reveals Rodin's conviction of the uselessness of completion and of the self-sufficiency of the fragment. As with *The Age of Bronze*, Rodin tended toward a simplification of the figure, eschewing the anecdotal – namely doing away with the cross – to concentrate on expression and movement. Rodin often analysed the depiction of movement, and rather than clinging to a form of realism which might require movement to be expressed by a raised foot, he preferred to suggest potential motion and an imaginary sequence of movements in each part of the body. A contemporary example of this was Rude's *Marshall Ney*, which Rodin had in mind when he worked out the model for his *Monument to General Margueritte* in 1884. This figure of a *Walking Man* in effect combines two stages in one: his feet are on the ground, one step having been made, while the pivoting of his shoulders and torso anticipate the next. As the sculptor explained to Paul Gsell: "The eyes naturally wander up from the legs to the raised arm, and as they

see the different parts depicted in sequential fashion along the way, they have the illusion of seeing the motion taking place." The mastery of movement was one of the triumphs of Rodin's art, and it culminated in his striding *Balzac*, which itself harks back to the *Saint John the Baptist*. *The Burghers of Calais* are also men walking, but Rodin's concern there was to go beyond this aspect for the sake of expression.

Exhibited at the Salon of 1880, the *Saint John the Baptist* earned Rodin an honourable mention; an unequivocal mark of official recognition. The figure was even purchased by the State in the following year. Thanks to the Undersecretary of Fine Arts, Edmond Turquet, this distinction was followed by a commission to make a door for the future Musée des Arts Décoratifs, his most important contract to date. This commission also included an official studio at the marble depository in the rue de l'Université. At the age of forty, with the necessary means now at his disposal and the obstacles to his talent having been removed, Rodin was ready to make his bid for fame.

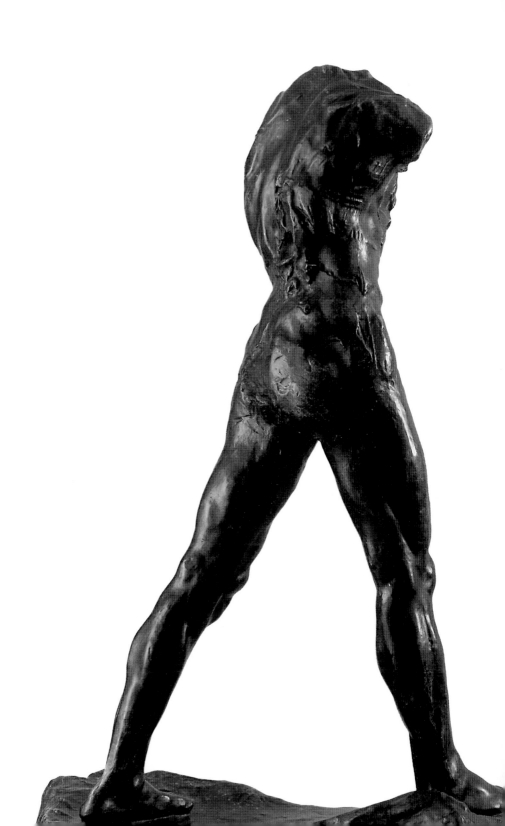

# of Hell The Gates

When Turquet boldy entrusted Rodin with the execution of bronze doors for the as-yet non-existent Musée des Arts Décoratifs, he not only granted a poor and controversial sculptor a measure of recognition overnight and the prospect of earning 8,000 francs, but he also left him free to choose a subject in keeping with his own aspirations. Rodin seized the opportunity and launched himself into a grandiose and original – if unmanageable – composition; a composition which took its inspiration from former times and departed from the mawkish tastes of his contemporaries. Starting out with a romantic subject, Dante's *Inferno*, he soon veered completely away from the literary references and elaborated a work in constant progress that became the crucible for his artistic creation over the next twenty years. This unfinished work was essentially an ode to sculpture, then still surbordinated to the other arts and to a general aesthetic mediocrity.

# A "Noah's Ark"

In the nineteenth century, sculpture was reduced to a "complementary art", as Baudelaire put it in his *Salon* of 1846, which must "humbly associate itself with painting and architecture to serve their intentions". This secondary, decorative function determined by an architectural programme was rarely called into question. A group like Carpeaux's *Dance*, which Rodin knew well, scandalized the public by its subject and energy; it seemed to burst out of the bounds imposed by the façade of the Opera. In his *Talks on Architecture*, Viollet-le-Duc deplored this state of affairs, whereby architects made room for sculptures without any concern for subject-matter or the coherence of the whole; all that mattered was the size of the statue. Rodin had to endure for many years the frustration of making decorative sculpture for this kind of project. He was

**The Gates of Hell**
*1880–1917, bronze, 6.35 x 4 x 0.85 m.,*
*Paris, Musée Rodin.*

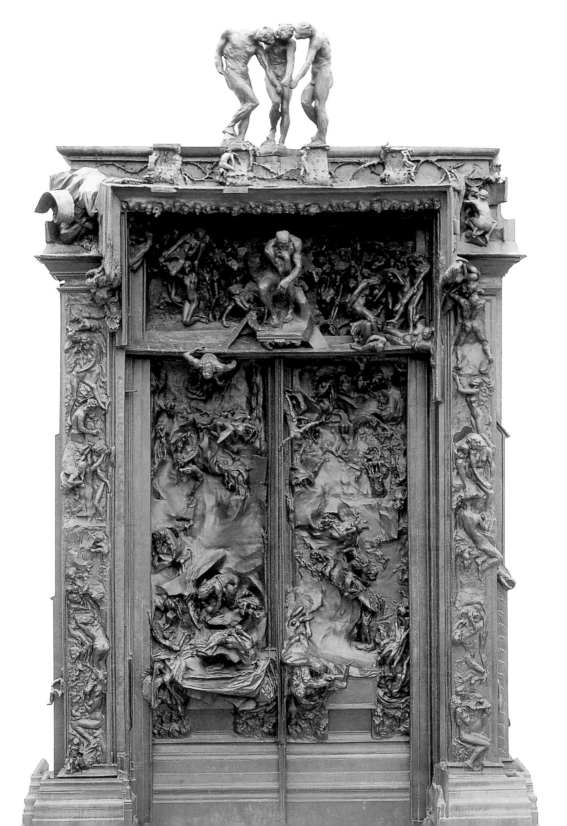

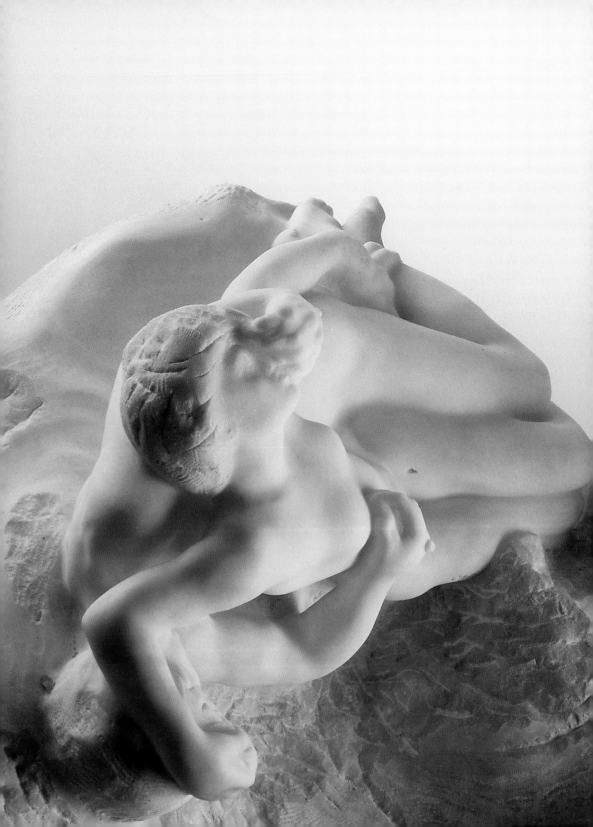

**Paolo and Francesca**

*1905, marble, 0.81 x 0.108 x 0.65 m.,*
*Paris, Musée Rodin.*

From the very first sketches, this pair of lovers
formed a major group occupying one of the doors
and was transformed into *The Kiss*. Rodin eventually
opted for a more tragic version of the couple.
Carved years later in marble, the couple seems
to emerge from the block like Adam and Eve
in *The Hands of God*.

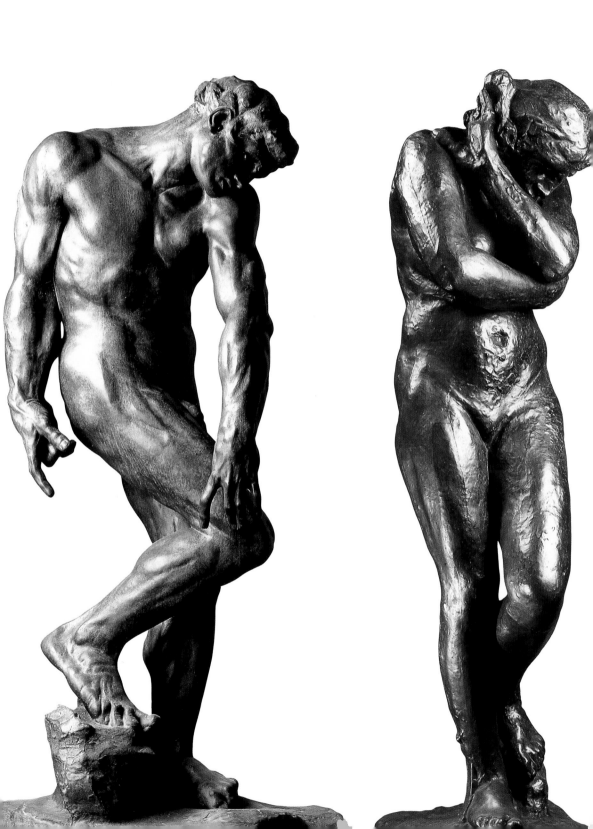

**Adam, or the Large Shade**
*1880, bronze, 1.961 x 0.765 x 0.78 m.,*
*Paris, Musée Rodin.*

**Eve**
*1881, bronze, 0.195 x 0.9 x 0.6 m.,*
*Paris, Musée Rodin.*

In one version, Adam and Eve flanked the *Gates*
like caryatids; Adam was subsequently developed
into *The Large Shade* and repeated three times
at the top. Eve became an independent figure.
The Original Couple decorated the salvaged façade
of the Château d'Issy, which was re-installed
in Rodin's garden at Meudon.

one of the 130 sculptors commissioned to work on the reconstruction of the Paris Town Hall. He sculpted a figure of d'Alembert that was installed in a first-floor niche on the north west corner of the building: it would have taken an even greater genius than Rodin's to attract any notice under such conditions.

In the case of the *Gates of Hell*, Rodin gradually lost sight of the overall context of the work. Thanks to his unbounded imagination, the composition proliferated fantastically until over 200 figures had found their place in it and many more were developed as derivatives. Fortunately – or unfortunately – as the museum remained unbuilt, Rodin no longer had to concern himself with the original programme. Taking on the scope of a cathedral door, and freed from the constraints of an official commission, the work took on a life of its own and became a reservoir of motifs, forms and groups – in the sculptor's own words, a veritable "Noah's Ark". Beyond that, these doors opened out onto the freedom of sculpture as a whole.

Rodin worked for twenty years on his *Gates* without ever finishing them. Already in October 1880, with the deed of commission having been signed on August 16, the artist had progressed enough to collect a first payment of 2,700 francs. Indeed, he had got to work immediately, and was able to benefit from all the sketches that he had worked out previously. Within a few months' time, the *Gates* were covered with groups, including a *Paolo and Francesca* and a *Ugolino*, which were the principal motifs in the first versions of the doors. On October 20, he applied for more funds, for he now considered enlarging the doors with a monumental figure on each side: an *Adam and Eve* in a disposition like Puget's caryatids. The doorway he planned would have been at least 4.5 m tall by 3.5 m wide. This grew to 6 m high and 4 m wide, without the lateral figures, which meanwhile had fallen by the wayside. He explained to the administrators that his doors "will include, with the bas-reliefs, many almost free-standing figures". Indeed, the sculptures seemed ready to break loose from their ground. There was a marked progression in depth; from the background emerged full or partial figures in relief or freestanding, some protruding quite far, like the *Amor Fugit* group in

the middle of the right door which seems almost completely detached from its ground. Other figures top the jambs, like the *Falling Man*.

The scope of this project and the addition of the figures of *Adam and Eve* led the Ministry to allocate Rodin a subsidy of 18,000 francs on October 31, 1881. Later, on the basis of reports by inspectors impressed by the scale of the work and the extremely detailed study of the figures, and even though its completion seemed less than certain, the government allocated him 25,000 francs, and then increased this figure to 30,000 francs. Yet he was awarded the balance of this sum only in 1917, thanks to the efforts of the curator of the Musée Rodin, Léonce Bénédite!

From 1880 until 1884 Rodin worked intensively on the *Gates*, then, little by little, detached the figures piecemeal, as if he preferred marketing them individually instead of letting the State's commission take all the glory. By 1884, however, the doors seemed to be ready, for a casting estimate was submitted. If no action was subsequently taken, it was because construction of the Musée des Arts Décoratifs was eventually suspended. Around 1888, Rodin took the project up again, but it continued to stall. Then he finally lost interest, went on mining its riches, and seemed to have wanted to empty it of most of its content by exhibiting it in 1900 with almost all of the most salient figures removed. In later years, he let himself be persuaded to return to his original concept, and this was the state in which this seminal work passed into posterity. Léonce Bénédite installed a complete plaster version in the chapel of the Musée Rodin in 1916, and the first bronze was cast for the Rodin Museum in Philadelphia in 1926.

**The Gates of Hell**
*Detail of the left door, bronze, Paris, Musée Rodin.*

Amid the tangle of bodies, *Ugolino and his Children* present a compact group that expresses the horror of starvation and the descent into bestiality. Below, *Paolo and Francesca*, locked in their embrace, suffer the pain of desire and the fear of being separated in this infernal realm.

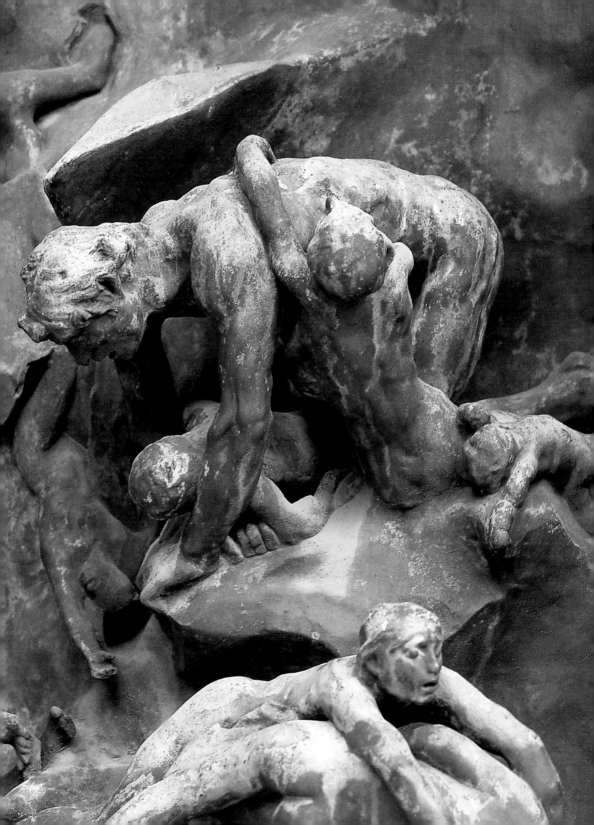

# A descent
## into Dante's Inferno

An avid reader of Dante's *Divine Comedy*, especially the *Inferno*, whose dark visions seemed attuned to his own inner atmosphere, Rodin decided to transpose this early-fourteenth-century poem into the medium of bronze. For this tour de force, he wanted to depict the innumerable scenes that mark the descent into Hell. A subject of this kind was rich in opportunities to express the passions, violence, despair, and the tumble of fallen souls in contorted, unbalanced, and even lascivious poses. For the *Divine Comedy*, which not only relates the famous love story of Paolo and Francesca da Rimini but also turns into a quest for love, was not devoid of sensuality: Dante, guided by Virgil, crosses Hell and Purgatory in search of Beatrice, and is finally united with her in Paradise.

Nevertheless, the evidence clearly shows that Rodin did not feel himself entirely bound by Dante's programme. He had already read the poem when he was at the Petite École, and had been haunted by it, as many drawings testify. Although they follow the text closely – for example, Virgil holding Dante – they did not become models for the sculptures, but remained studies, and the sketches in clay gradually developed independently of the text, save for several very specific groups. Rodin never made any secret about this,

**The Three Shades**
*1881, bronze, 0.966 x 0.92 x 0.541 m.,*
*Paris, Musée Rodin.*

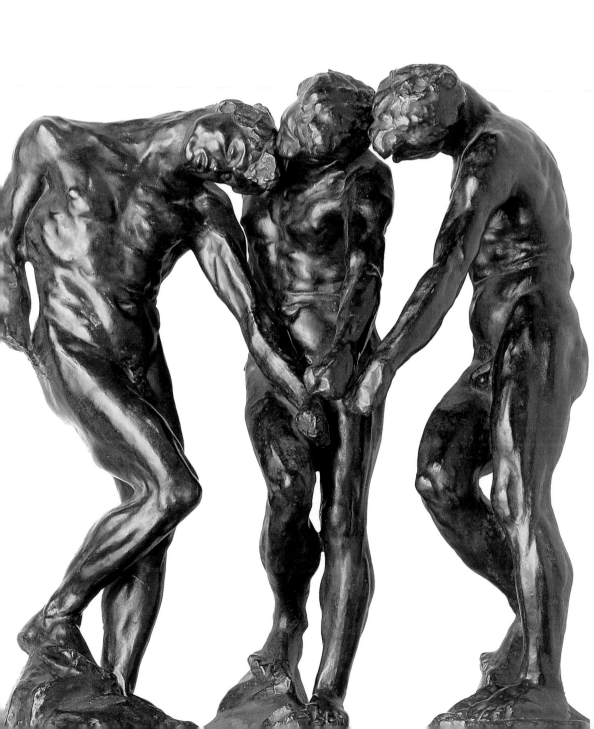

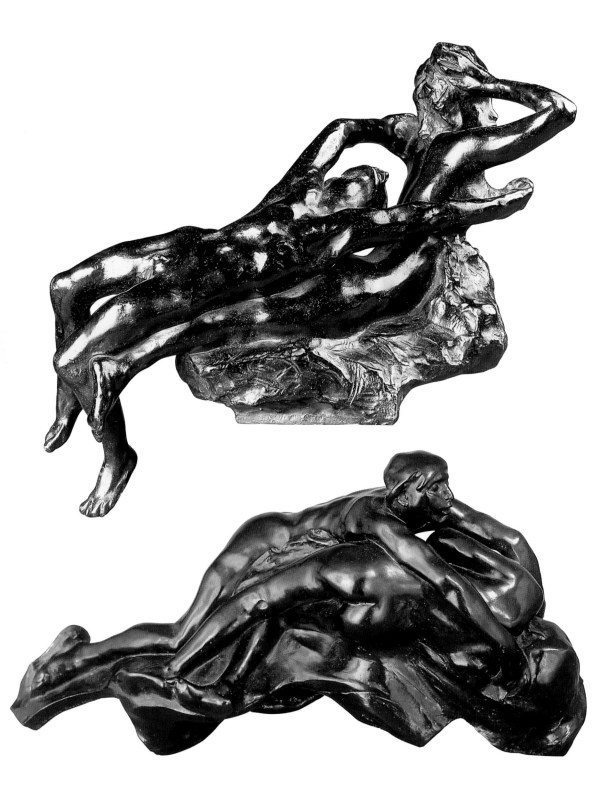

**Paolo and Francesca**
*1867, bronze, 0.301 x 0.604 x 0.3 m.,*
*Paris, Musée Rodin.*

69

**Amor Fugit**
*Around 1884, bronze, 0.3 x 0.51 x 0.19 m.,*
*Paris, Musée Rodin.*

and, although he had described Dante as a 'literary sculptor', he told his biographer, Truman H. Bartlett:

"My idea was not to interpret Dante, although I was glad to use the *Inferno* as a starting point, because I wanted to do something with smallscale nude figures. I was accused of taking casts from life... To prove once and for all that I could model after nature as well as anyone, I resolved, in my naiveté, to make the sculptures on the door smaller than lifesize."

Technical considerations were therefore also an aspect of his choice. In any event, the choice of subject-matter placed him among the heirs of Romanticism.

Dante had been a major inspiration to the Romantics, and, accordingly, Rodin showed affinities with the style of the masters of his youth. He was certainly aware that Delacroix had made his mark in 1822 with his *Barque de Dante*. A wax sketch by Auguste Préault (1809-79) titled *Dante and Virgil in Hell* could be considered a preparatory sketch for Rodin's figures: there is a tangle of bodies, embracing couples, nudes strung in bold arabesques, and a seated giant. *Paolo and Francesca* are clearly set off from the standing figures of *Dante and Virgil*. Even the torsos are stretched in a pose that became one of Rodin's favourites; examples being the *Torso of Adèle*, *Francesca*, and *Amor Fugit*. Like himself, Préault had been a victim of the Salon juries because his works were considered too shocking, and he had seldom been able to cast them. Préault also created fragmentary works, like *Slaughter* (*Tuerie*, 1834), and wrote: "I am not for the finished, but for the infinite." This shows the profound bond that linked Rodin with the Romantic generation's quest for expression, movement and freedom. This infinity was to become Rodin's own motto, and the basis of his art as a whole.

What remains of Dante is the atmosphere, the teeming bodies of the tormented, and groups like *Paolo and Francesca* and *Ugolino and his Children*. The artist thus took many liberties with the text, transforming certain subjects and adding figures from his own imagination, or from other sources, like Ovid's *Metamorphoses*. Thus *Avarice and Lust*, below on the right door, belong to the Dantean cast of characters, but the text presented each of the Vices in a separate circle of Hell. Rodin's juxtaposition introduces a new meaning: the miser's treasure is in fact a woman. Possession has erotic connotations.

To be sure, Dante mention centaurs in Canto 12, and many drawings exist attesting to Rodin's fascination with these hybrid creatures (which he shared with German artists like Arnold Böcklin and Franz von Stuck). But in his work, they owe more to Ovid and traditional representations of the Battle of the Lapiths and the Centaurs than to Dante. A frieze of centaurs should have framed the doors, but the only trace of this is the centaur on the left pilaster embracing a woman. A marble of a female centaur (*Centauresse*, 1889) became

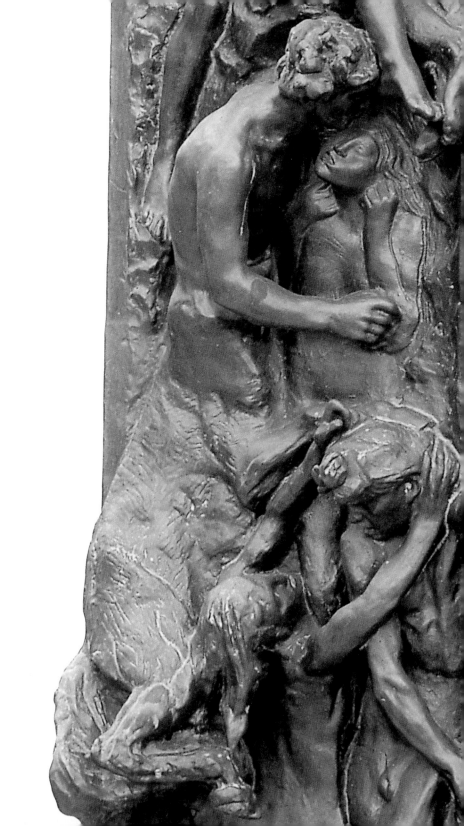

Previous pages:
**The Gates of Hell**
*Detail of the left pilaster showing the centaur and embracing couples, bronze, Paris, Musée Rodin.*

**Centauress**
*1887 or 1889, bronze, 0.4 x 0.45 x 0.18 m., Paris, Musée Rodin.*

**The Gates of Hell**
*1880-1881, sketch for the composition, Paris, Musée Rodin.*

one of his successful pieces. Another work titled *The Body and the Soul* suggests that the centaur kept for him the classical meaning of a creature torn between Spirit (the human half) and the Flesh (the animal half).

There are also cases of figures inspired by Dante and the project for the doors, but without ever having been intended for them. Thus the figure of a *Succubus* (also called *Hecuba Barking*, 1889) was taken from a Trojan legend, as well as from the *Divine Comedy*, which in Canto 30 described Hecuba as howling relentlessly like a dog. That he left this monster out is explained by the fact that he wanted to eliminate the explicit props and decors of Hell: no snakes, no devils, no fantastic creatures. Nor did he want to depict any hellish visions, like the tormented and mutilated bodies described by Dante. Even the lower panels with representations of *Grimacing Mourners* were left out in the end. The torments of the damned are purely spiritual, internal, and betrayed only by their attitudes and their taut muscles. The female figures are physically beyond reproach, full and desirable. The damned are musclebound and athletic in appearance. They are

so distantly related to Dante's skeletal souls that Rodin will be able to integrate them into other compositions and contexts without modification. Thus the *Fallen Caryatid*, at top left, is related to the misers in the Fourth Circle who are condemned to carry rocks (Canto 7), while also being the sensitive study of a kneeling woman. Her body brims with life in spite of the crushing weight that she must bear.

Rodin's *Gates of Hell* are indeed a "Noah's Ark", together with a danse macabre that is closer to a Bacchanalia than to a Last Judgement. They are the profoundly transformed avatars of the traditional Christian theme of Hell, changed into a pretext for representing a world so charged with eroticism that even Félicien Rops, the recognized master of the genre at the time, was taken aback.

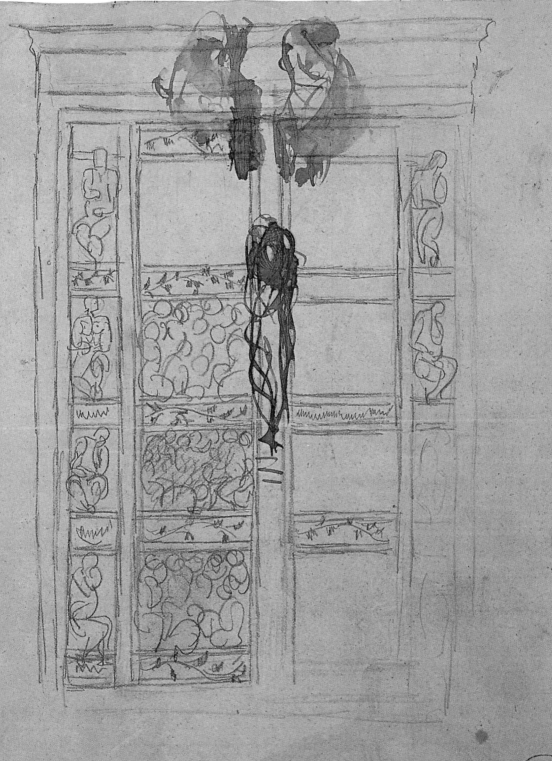

# Learning from
## the Florentines

This accumulation of female figures shows a great variety
of attitudes in a composition before *The Thinker* was added.
A number of these figures will be isolated to make
individual works: the woman at left with arched back,
the *Kneeling Faunesse*, *The Martyr* (left, somewhat behind),
and *Meditation*, leaning on the lintel's right pillar.
This lintel was an inexhaustible store of forms.

Like the subject-matter taken from Dante's epic
poem, certain formal and compositional elements of
the *Gates* belonged to the world of the Florentine
Renaissance. Rodin not only rediscovered his prede-
cessors, but also rivalled with them. He told his
secretary, René Chéruy: "In Florence, I saw the doors of
Ghiberti and studied Michelangelo." This prestigious
kinship was noted by all of his contemporary com-
mentators. Octave Mirbeau, who began a sort of
crusade to champion Rodin in 1880, wrote in *La France*:
"Those who have been able to admire the artist's fin-
ished studies and those still underway in his studio
agree that these doors will be the major work of this
century. One must go back to Michelangelo to find so
noble, so beautiful, so sublime an art." Then he com-
pared the *Gates* to "those of Lorenzo Ghiberti, of which
Michelangelo said they were worthy of being the Gates
of Paradise".

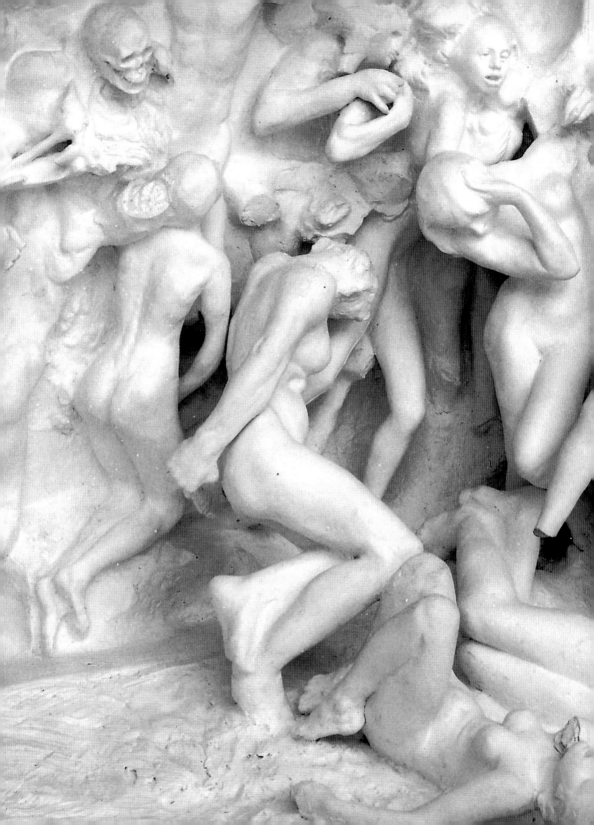

**The Gates of Hell**
*1880-1881, sketch for the composition,*
*Paris, Musée Rodin.*

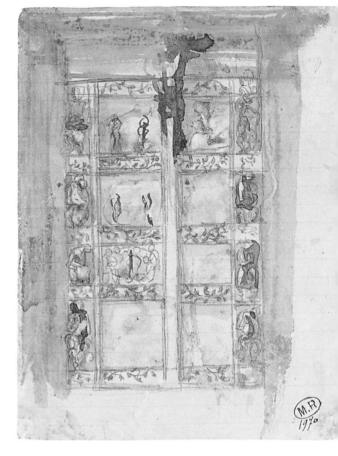

The second model, plaster, 0.17 x 0.14 x 0.02 m.
(6 5/8 x 5 1/2 x 3/4 in.), shows the main groups
then planned. At the top, Dante and Virgil: at the
bottom left, perhaps Ugolino; on the right, Paolo
and Francesca (*The Kiss*).

Following pages:
**The Gates of Hell**
*Detail of the left pilaster, bronze,*
*Paris, Musée Rodin.*

**MICHELANGELO**
**Rebellious Slave**
*Executed for the tomb of Jules II, 1513,*
*marble, height: 2.15 m.,*
*Paris, Musée du Louvre.*

Rodin turned to Michelangelo not only for his
compositions, but also for the athletic power
and accentuated torsions of his figures.

Ghiberti executed two doors of the Baptistery of San Giovanni in front of the Florence Cathedral. The better-known of the two, the *Gates of Paradise* (1425-52), is composed of ten bas-relief panels depicting scenes from the *Old Testament*. Their influence is visible in the first sketches Rodin made on paper or in clay: a panel arrangement which features the two most often depicted subjects of the *Inferno*, Paolo and Francesca and Ugolino. Fettered by the separations and compartments, Rodin gradually reduced the number of divisions, until all that remained in 1882 were two large open panels beneath a lintel. His development paralleled that of Italian Renaissance art, which began with scenes superimposed in panels and evolved towards frescoes occupying the entire wall space without any separating elements: the Sistine Chapel is a good example, for the walls and ceiling are still compartmentalized, whereas the *Wall of the Last Judgement* was conceived by Michelangelo as a single space. This left the artist free to devise a grand composition.

Michelangelo's obvious influence involves not only the tangled masses of bodies and the combination of classical Hell realms with Christian themes, together with the tension and torsion of the nudes which the apocalytic subject-matter justifies, but also certain motives that Rodin developed in his own idiom. Glaring analogies have been pointed out, like between his *Thinker* and Michelangelo's *Pensieroso* at San Lorenzo, and more subtle borrowings, like the pointing finger of Adam which originated in the *Creation of Adam* in the Sistine Chapel, or the positions of the limbs and sharply bowed head, which allude to the *Pietà* in Florence and to the *Slave* figures. The great diversity of bodily attitudes of the damned and of the ignudi of the ceiling is also to be found in Rodin. The difference is that Michelangelo would never have permitted himself so many repetitions. This, however, became one of the principles of the *Gates of Hell*.

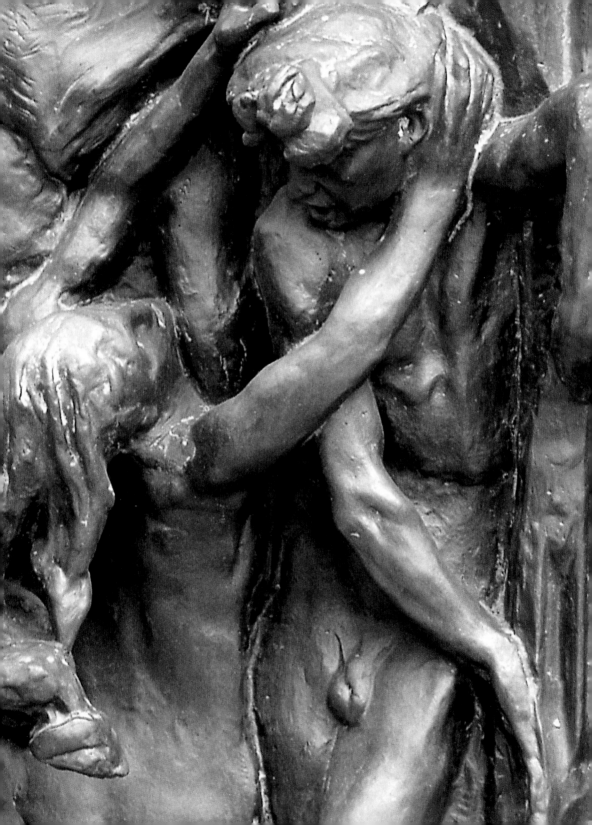

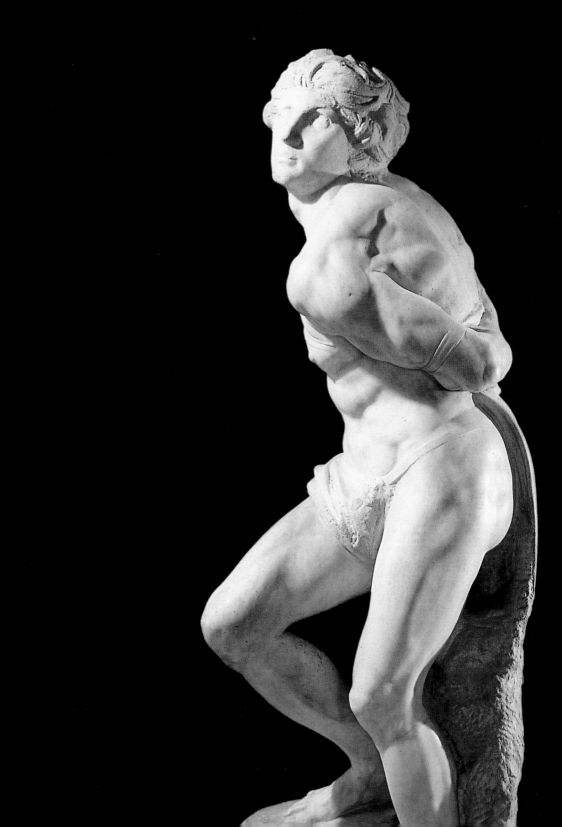

**The Gates of Hell**
*Detail of the* Fugit Amor *group, bronze,
Paris, Musée Rodin.*

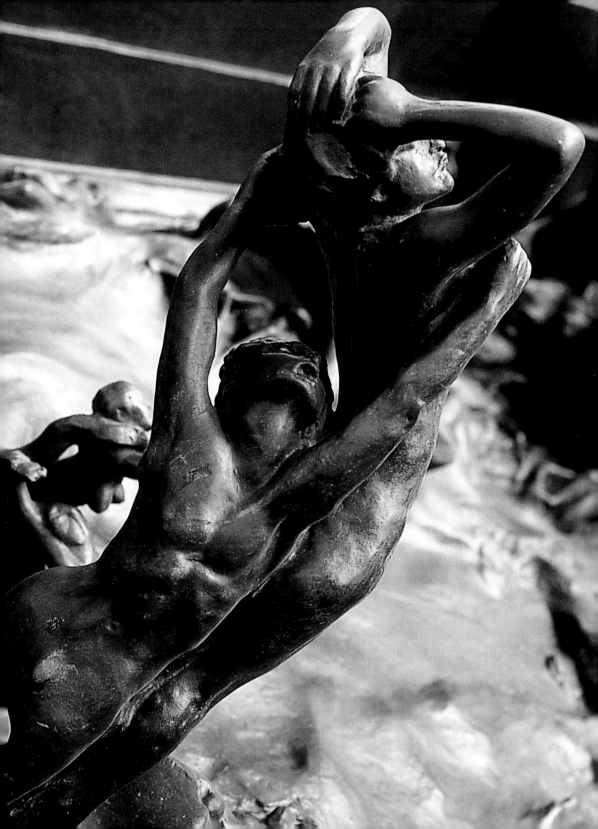

# The Gate,
## a reservoir
### of forms

IV

Proliferation is one of the most salient features of the *Gates of Hell*. As Edmond de Goncourt noted in his *Journal*: "On these two immense panels there is nothing but a tangled, intertwined mass, something like the concretion of a bank of madrepores." These bunches of human figures grew not only out a fertile imagination, but from the free use of "already-made" works which the artist separated, recombined in new groups, and reproduced exactly or with minor variations, in a seemingly endless series.

# Marcottage and multiplication

This practice – known as marcottage – and repetition were fundamental to Rodin's compositional approach: he used figures like a sort of vocabulary. Faced with a major commission, Carrier-Belleuse also made use of this technique. With Rodin, however, it was not just the solution to the problem of mass-production, but a veritable compositional principle whose modernity is more evident to us today than it was to his contemporaries, some of whom dismissed it as laziness. The Musée Rodin in Paris preserves a number of these conjoined, sometimes bizarre casts.

The sculptor worked out the composition by combining figures and fragments, even letting himself be guided by chance. He would single out certain parts, re-work them or set them aside. He kept plaster casts – sometimes in several copies – of all the works, sketches and pieces he deemed satisfactory. Rodin sometimes went even so far as to combine his own

**The Gates of Hell**
*Detail of the right pilaster, bronze, Paris, Musée Rodin.*

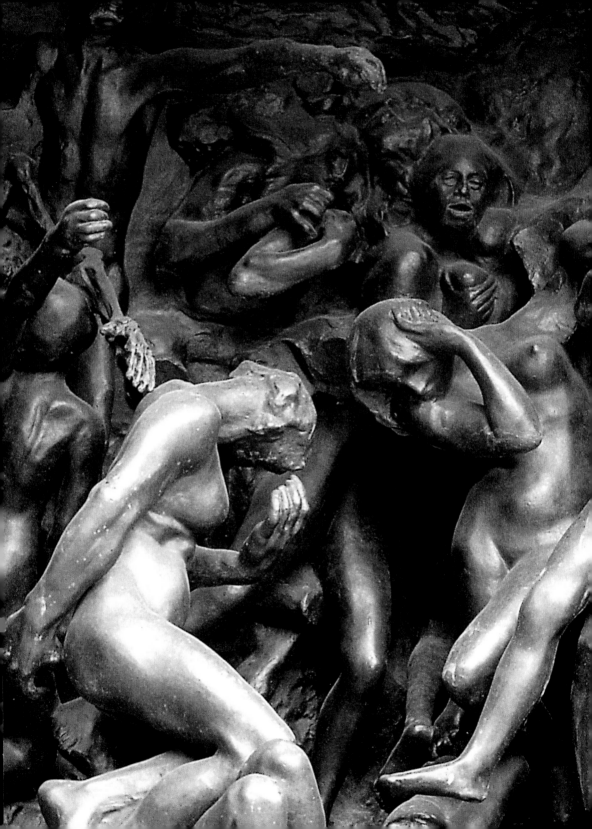

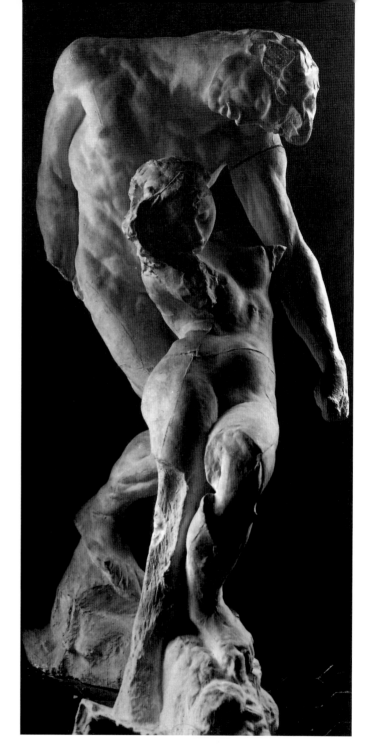

**Composition with the Large Shade
and Meditation**

*Photograph by Bulloz, Paris, Musée Rodin.*

Rodin kept many plasters to experiment
with in group compositions.
Here the mutilated figures are arranged
like the models who posed for this
photograph.

**Two male models**
*Anonymous photograph,*
*Paris, Musée Rodin.*

figures with objects into a novel composition; this was the case for the marble of the *Little Water Fairy*, which began with the association of one of his figurines and an antique vase.

The threefold repetition of *The Large Shade*, itself an offshoot of the Adam figure, produced the *Three Shades* that top the portal. Although suggested by the episode in the *Inferno* of three shades who tell their tale, the effect intended was primarily formal. It mattered little that there was repetition, that the right arms were just shapeless stumps, or that the trio's pre-sence there complicated the meaning: the composition needed to be balanced by an axial group at this spot.

*The Gates of Hell* offers one of the greatest variety of applications of the marcottage technique. The figure of *The Martyr* is an extreme example of repetition: its face can be seen a dozen times on the doors, in particular in the frieze of heads that crowns the lintel. The whole figure re-appears in the group of *Orpheus and the Maenads*, which was itself developed from the lintel, then in *Orpheus and Eurydice Leaving Hell*, where, as Alain Beausire noted, "its expression of extraordinary suffering and hope of redemption" is totally appropriate. It hovers over the *Orpheus Imploring* that was exhibited as a plaster at the Salon of 1908, and was to be further used in decorative compositions. A winged version of *The Martyr*, described as *Fortuna*, was already featured on the left door. Then, in 1895, winged again, it did service for a *Fall of Icarus*. The marble version of this piece, produced in the following year, was dubbed more logically: *Illusion, the Sister of Icarus*. The public was not so carefree as Rodin in accepting the transformation of a female figure into a male hero.

*The Falling Man*, the *Prodigal Son*, *Meditation*, and *Torso of Adèle* were also used in many different combinations or contexts. Entire master-pieces came directly from the *Gates of Hell*.

# Independent works from
# The Gate

**Ariane**

*Plaster, 0.21 x 0.56 x 0.26 m.,*
*Meudon, Musée Rodin.*

**Torso of Adèle**

*1882, plaster, 0.131 x 0.448 x 0.205 m.,*
*Paris, Musée Rodin.*

Rodin celebrated the beauty of his model Adèle Abruzzesi and her sister; arched to bring out its bold curves and contours, this figure modelled for the *Gates* was used frequently in sensual groups like *Eternal Springtime* and *Fallen Angel*.

A large number of the groups from the 1880s, and even the 1890s, were developed from the *Gates of Hell*, either by enlarging a figure isolated from the whole and giving it a new meaning through a new title, or by the elaboration of figures and groups in the spirit of Dante, and more generally of the *Gates* themselves. Thus the famous *Thinker*, the keystone of the composition, was such a powerful figure in itself that it could stand on its own and become a recognized masterpiece. The same could be said of *Ugolino*, *Adam and Eve*, *The Helmet-Maker's Wife* (*La Belle Heaulmière*), and the *Danaid*. All of these works retained from their original context a specific power and sensuality. With the *Gates*, Rodin found his true subject and the compositional principles that would inform the rest of his work. Only with the statues made for major commissions did Rodin start from scratch and invent new forms, like the *Burghers of Calais* and *Balzac*, which stand as exceptions to this rule – or seem to.

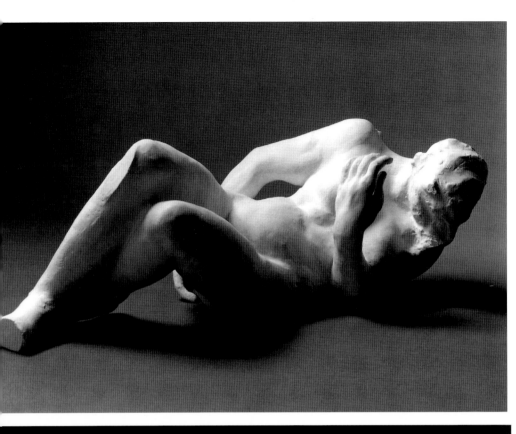

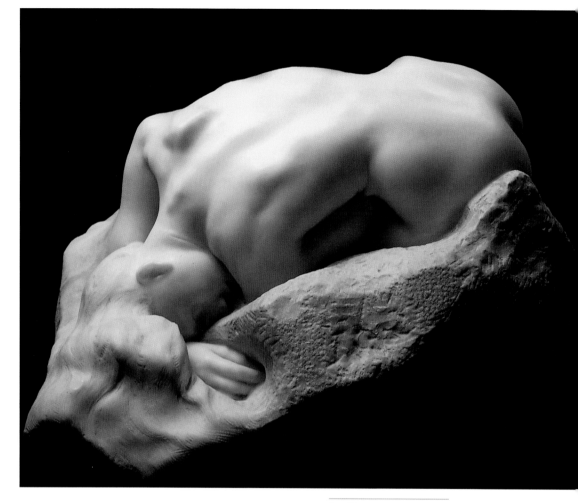

**Danaid**

*1885, marble, 0.35 x 0.72 x 0.57 m.,*
*Paris, Musée Rodin.*

The texture of the marble enhances the undulating
forms of this, one of Rodin's finest nudes; the
harmonious contours and flowing hair are perfect
examples of the Art Nouveau aesthetics to which
Rodin also responded.

**The Prodigal Son**

*1886, bronze,*
*0,56 x 0,245 x 0,290 m.,*
*Paris, musée Rodin.*

Derived from the *Gates*, this figurine fascinated
the sculptor because of its strained musculature
and gesture of imploration; it was re-used in *Fugit Amor*.

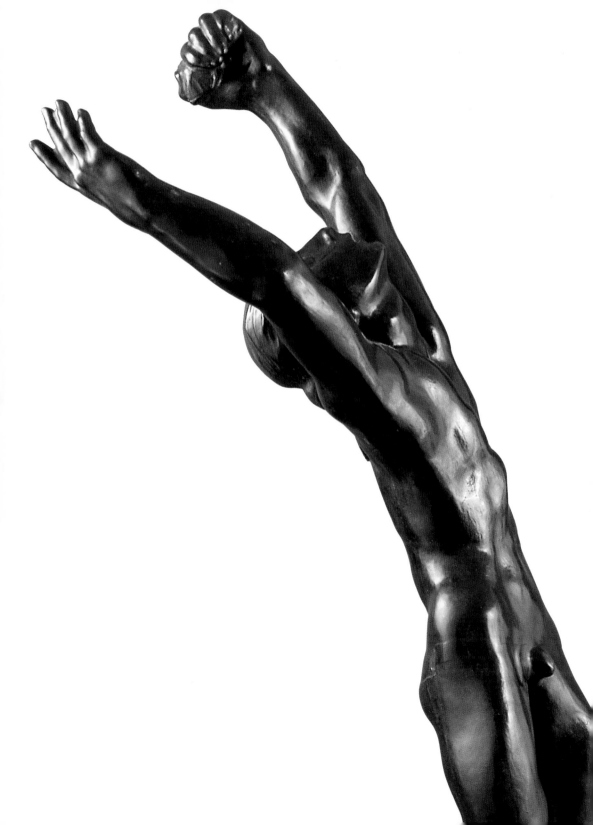

# The Thinker

The figure of *The Thinker* is the most obvious example of Rodin's progressive detachment from Dante. His drawings show that Dante was supposed to appear (without Virgil) on the doors. Seated on a rock in the middle of the lintel, the only stable element in the maelstrom of figures, the poet contemplates the souls of the Damned. The reference to Dante persisted at least until 1885, for Mirbeau wrote in that year: "*The Dante* is seated, his head leaning forward, the right arm resting on the left leg, which impresses on the nude form an ineffably tragic movement." Soon after, however, Dante was dropped in favour of a more universal dimension in the figure: with his contained force, his muscular torso worthy of the Belvedere, this male nude absorbed in meditation embodies *The Thinker* along the lines of Michelangelo. Rodin explained this transformation:

"In front of this door, but on a rock, deeply absorbed in meditation, Dante works out the outline for his poem. Behind him are Francesca, Paolo, and all the characters of the *Divine Comedy*. This project came to naught. Thin and ascetic in his straight robe and isolated from the whole, my Dante would have had no meaning. Following my original inspiration, I executed another 'Thinker', a male nude sitting on a rock, toes

**The Thinker**
*1889, coloured plaster,*
*1.823 x 1.08 x 1.413m., Paris, Musée Rodin.*

This figure, which has become a symbol of Rodin's work as a whole, was originally intended to be Dante posed as centrepiece for the *Gates*; it embodies man reflecting on his fate, and the creator on his creation.

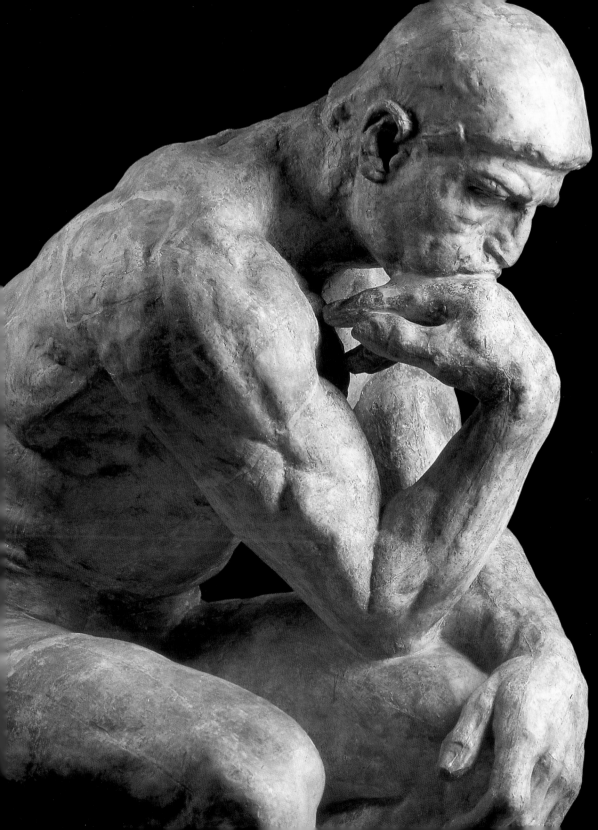

clutching the edge. His head on his fist, he wonders. Fertile thoughts slowly rise in his mind. He is not a dreamer. He is a creator."

This shift shows how, from the transposition of a literary theme, be it from Dante, Ovid or Baudelaire, Rodin sought to express the universal. This was all the easier as he was not bound to illustrate anything, but just model bodies and assemble them into compositions bringing out their qualities. For the public, *The Thinker* became an icon of man meditating upon his fate and preparing for action. The career of *The Thinker*, in sizes large and small, was launched. Its erection in front of the Pantheon on April 21, 1906 marked a triumph for Rodin, who was later to be buried under a copy of this statue in Meudon. This was poetic justice enough, for it had its origin in Michelangelo's *Penserioso* figure on the tomb of Giulano de Medici. The "creator" in this case was Rodin, and he had no more interest than Michelangelo in making the resemblance between model and figure coincide.

**The Thinker**
*1880, bronze, 0.719 x 0.451 x 0.562 m.,*
*Paris, Musée Rodin.*

Following pages:
**Inauguration of The Thinker in front of the Pantheon**
*21 April 1906, photographed by Hutin,*
*Paris, Musée Rodin.*

Consecrating the sculptor's glory, *The Thinker* was installed in the middle of the Pantheon's façade.

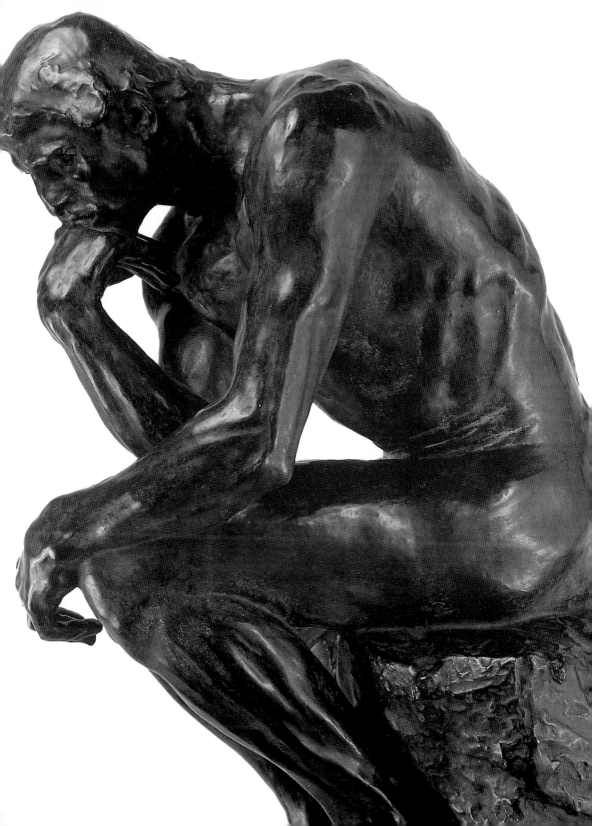

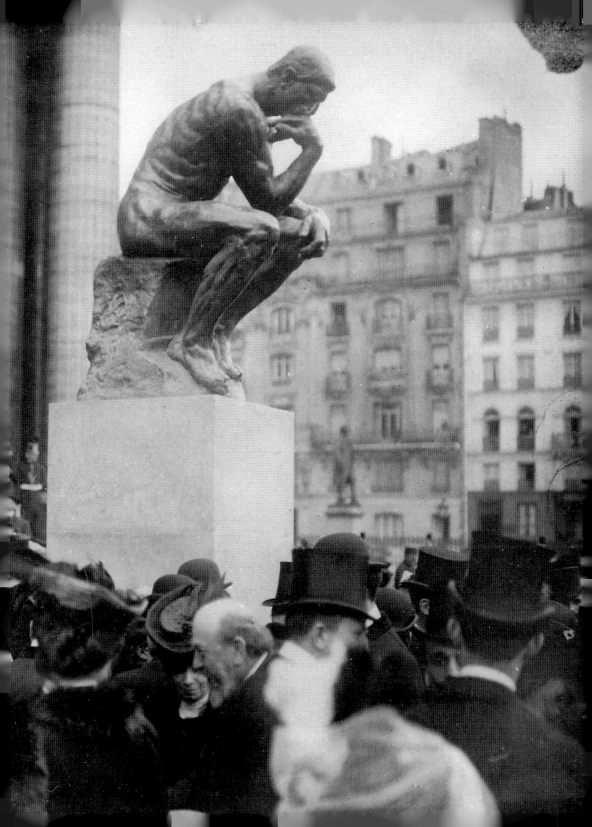

# Ugolino

The figure of Ugolino, the tyrant of Pisa who was jailed in a tower and who, tormented by hunger, devoured his dead children (Canto 33), had already appealed to Rodin in Italy. A sketch of this figure dates from 1875; the fragment which remains, inspired by the *Belvedere Torso*, seems to have been a first step in the conception of *The Thinker*. Before him, Jean-Baptiste Carpeaux had executed a gripping version of this subject and exhibited it in 1862. It depicts the horror of hunger, on the second day, with Ugolino biting his hands, while his terrified children tell him that they would prefer him to eat them!

Rodin chose the most crucial point, on the seventh day, when, his children dead, Ugolino crawls about like a wild beast, just before setting down to devour them, a scene which he could no more bring himself to represent than Dante. With the contained energy of an antique *Laocoon and His Children Strangled by Snakes*, Ugolino, still being held by one of his children, looms above their bodies like a wolf. The artist represented the power of his muscles, and his face ravaged by hunger and madness. As an anatomy lesson it is rather extreme, but justified because of the thinness of the figure. The bodies of the children are contorted with the pangs of hunger. Rodin broke completely away from the pyramidal composition of Carpeaux, choosing instead a cubic volume, as he had for his *Burghers*.

**The Gates of Hell**
**Ugolino and his children**
*Paris, musée Rodin.*

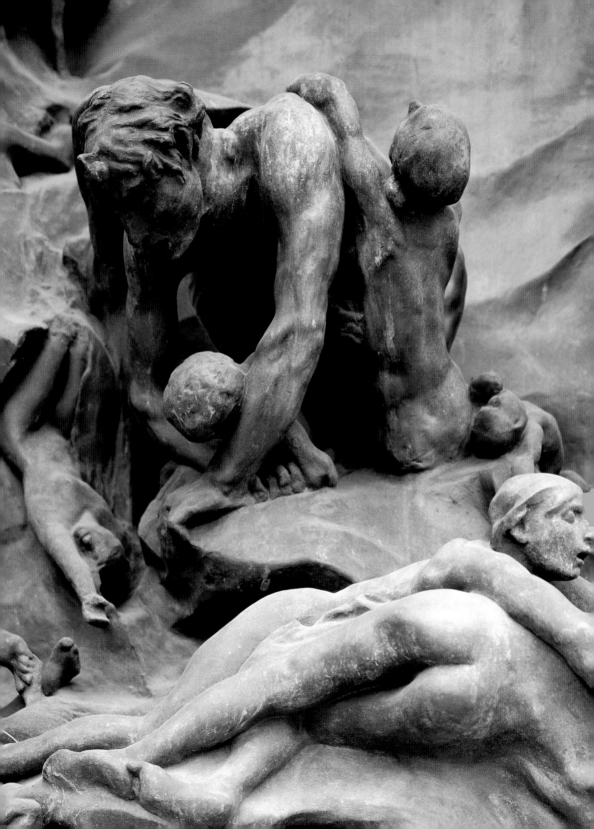

# Adam
## and Eve

At the Salon of 1881, Rodin presented the plaster of a figure which he titled *The Creation of Man*, and which was nothing other than his *Adam*. It was in the same vein as the *Age of Bronze* and its theme of awakening, for it showed: "Adam painfully stretching to free himself from the clay out which he was made". Upon his return from Italy, Rodin had modelled an Adam inspired by Michelangelo. In a talk with Paul Gsell in 1907, to illustrate the Florentine master's modelling technique, he reproduced his own *Adam*!

As for Eve, she is represented after the Fall. With her crossed arms, she recalls the *Eve Expelled from Paradise* on the Sistine Chapel ceiling. Before christening her Eve, Rodin called her the woman with crossed arms. The fulness of her body suggests that the model herself was pregnant. According to an anecdote told by Judith Cladel, the novelist's daughter who wrote several books singing Rodin's praises, the young Italian girl who posed for him had made no mention of her pregnancy and so the artist had to keep changing his figure until she finally revealed the truth about her condition. Rodin kept the statue in this state, finding it a fitting portrayal of the mother of humanity.

Rodin re-used the figures of *Adam and Eve* on a fireplace commissioned by a rich South American in 1902. They appear there as caryatids in an arrangement which recalled their original place in the *Gates of Hell*. To enhance their symmetry, Eve was given the same proportions and pose as Adam (but inverted).

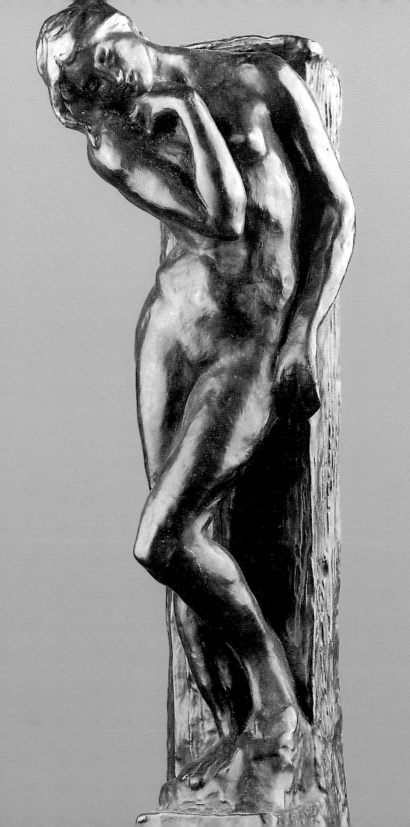

# La Belle Heaulmière and
# Danaid

The 82-year-old mother of Italian model who posed for Rodin had struck the artist by her decrepitude, ugliness, and a "character" that made her noble and worthy of being sculpted. This realistic work from 1884-85, in which he seemed to be referring to the Hellenistic tradition of the *Drunken Old Woman* and to the memento mori, was an opportunity to depict the expressivity of the body, even aged. Integrated into the left pilaster of the *Gates*, the emaciation and sorry physical state of the figure necessarily inspire reflections on the contrast that exists with the graceful figures all around it. Different titles keyed the sculpture in this sense: *Winter*, and *The Old Courtesan*, but the reference to Villon's ballad (*La Belle Heaulmière*) associated it with the figure of an old courtesan mourning her bygone charms. It was believed that this had been Rodin's source, but the fact is that this title was apocryphal, and although it enriches the significance of the figure, it obscured the artist's intention. How many female figures were christened *Venus* or *Eve* with the sole purpose of being made presentable at the Salon?

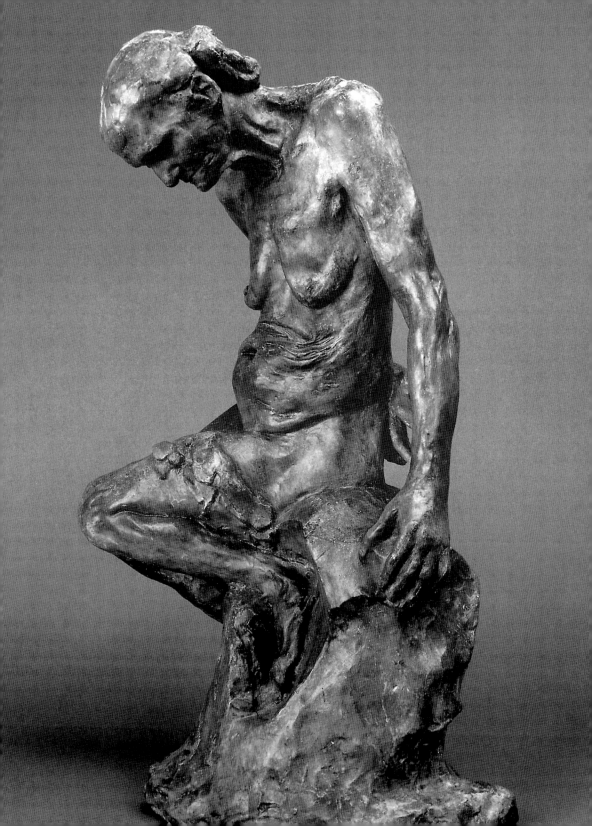

Two student-assistants of Rodin, Camille Claudel (1864-1943) and Jules Desbois (1851-1935) created versions of old women which are interesting to compare to the master's. Camille Claudel's *Clotho* (1893) is a Symbolist work that shows an old crone who embodies Destiny and mixes her own hair with the threads she is spinning. Jules Desbois' *Misery*, both in the terracotta of the Musée Rodin and in the wood version in the museum in Nancy, displays an extreme naturalism which verges almost on the expressionistic. This work was executed in 1894-96 and clearly betrays the influence of Rodin, with whom Desbois worked for thirty years. However, it must be said that anecdotal details like the tattered clothes would have been avoided by the master. The political slant given by the title has to do with Desbois' convictions, for he had had direct experience of social misery. There is a grain of Expressionism in Rodin's work, but it did not become a theoretical issue, for he was more concerned with artistic truths than with political or symbolic messages. At the opposite pole from the ugliness of *Clotho*

or *La Belle Heaulmière*, was the *Danaid* ; one of the works which most appealed to the Salon public. The presence of this magnificent nude with streaming hair seen from the back could be justified in this infernal realm partially drawn from Greek mythology. Having murdered their husbands, the Danaids were condemned to fill a pierced barrel; yet none of this is evoked by the figure. The woman's despair is expressed by her twisting position, which permitted an exaltation of the female body and the study of a back as beautiful as the one painted by Delacroix in *The Death of Sardanapalus* (1827). Rodin's figure displays an accentuation of form and a fluidity not unrelated to Art Nouveau. The sculptor was able to give – or instruct his assistants to give – the marble the appearance of a wavelike motion.

Rilke, as a fin-de-siècle poet, was very sensitive to these undulating forms and, in the *Man with the Broken Nose*, had already noted the artist's ability to render a never-ending motion; not just the movement of the *Walking Man*, but of matter itself, the fluidity of

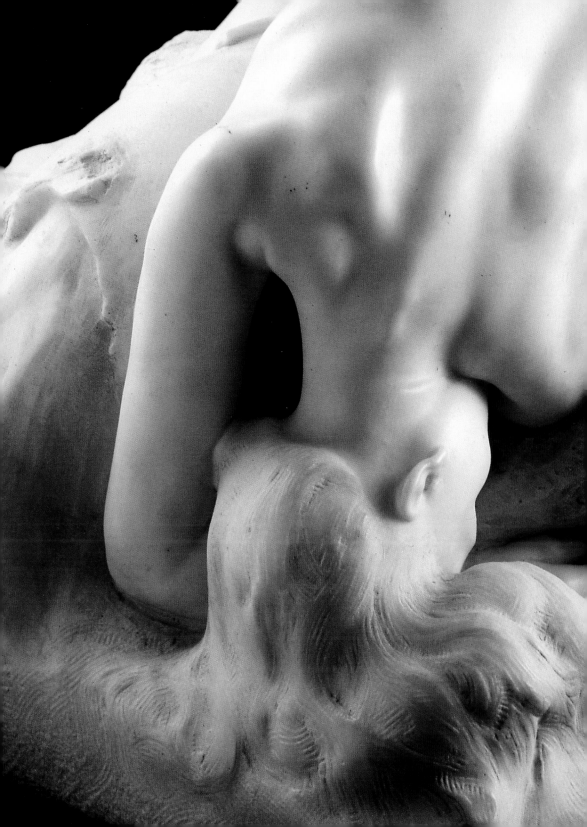

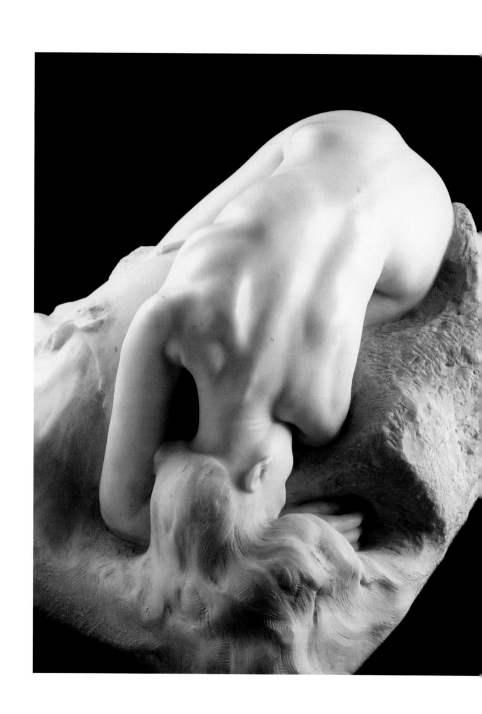

**Danaid**
*1885, marble, 0.35 x 0.72 x 0.57 m.,*
*Paris, Musée Rodin.*

the stone. He admired "this Danaid who from her knees has thrown herself into her liquid hair", and added: "One experiences a marvellous impression just from walking around this marble; the long, very long way around the curve of this richly unfurled back, towards the face which loses itself in the stone like a mighty sob, towards the hand which, like a final flower, speaks one last time of the sweetness of life, at the core of this eternal block of ice." The same qualities, heightened by extreme poses, are to be seen in the *Fallen Caryatid* and the *Fallen Angel*.

This fondness for flowing lines also constituted a limit, for a number of marble sculptures by Rodin fell prey to the nebulous sentimentality of the turn of the century. The *Andromeda* from 1885 presented a scaleddown variation in bronze of the *Danaid*; but, apart from the aquatic associations, this title was purely arbitrary.

The ever-increasing number of female nudes in the *Gates*, especially around the figure of *The Thinker* on the lintel, and their general ubiquity in the sculptor's work starting in the 1880s, proves conclusively that the theme of love and sensuality was at the heart of his quest. There were evidently personal overtones in this erotic free-for-all, in this obsession with femininity which some have qualified as "erotomania".

# The sculptor
## of woman
### and love

All the people who visited Rodin were struck by the many statues
of women and embracing bodies that had come out of his hands.
The director of the Hamburg Kunsthalle, Alfred Lichtwark was to write:
"He has become a fashion, and sells by the dozen individual subjects
extracted from his *Gates* and carved in marble. In his studio you can
always see five or six of these small embracing couples in every
conceivable posture ... The worst of it is that these dishevelled motifs
have their justification within the context of the *Gates*, but taken
separately, *The Original Sin*, *Damnation*, and *The Last Judgement*
are often just plain indecent."
This remark by itself is revelatory of the ambiguity underlying bourgeois
art: there is nothing shocking about presenting a nude, a female bust,
or a pair of lovers as figures of the Damned; the fiction of damnation, like
references to mythology, legitimized erotic representations. But an
isolated female figure appeared unwholesome in the eyes of the
contemporary beholder. Examples are the *Kneeling Fauness*, arms held
high to free the bust, *Meditation*, with her graceful turn of the waist, and
the *Torso of Adèle*, whose arching back sets off her full breasts. All of
these bodily motifs charged more with pleasure than pain were endlessly
reworked. Rodin's sculpture, a hymn to unfettered nature and desire,
provided some of the strongest images of physical love of the late
nineteenth century. Their origin was in the *Gates of Hell*, but Rodin
eventually freed himself from this context to produce such daring nudes
as *Iris, Messenger of the Gods*, or figures of crouching or damned women.

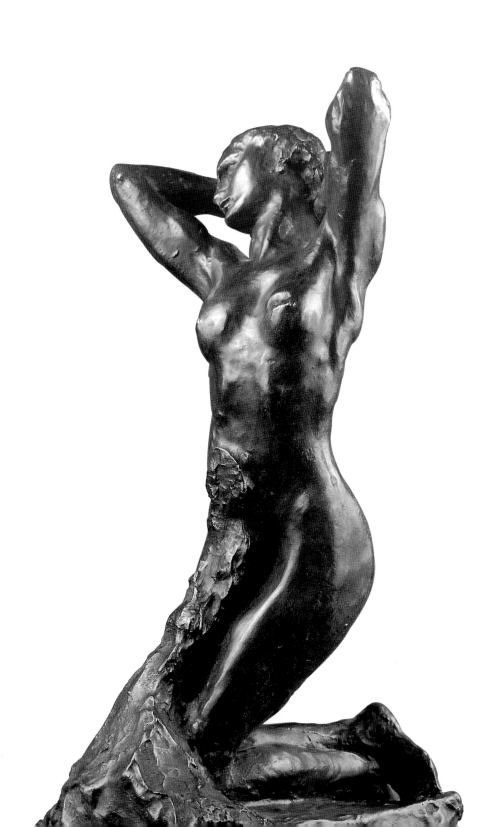

# Paolo and Francesca or
# The Kiss

The amorous couple *Paolo and Francesca*, often represented in nineteenth-century iconography, went through a profound transformation in Rodin's hands. Where Gustave Doré, in his illustration for an 1861 edition of *The Divine Comedy*, merely transposed the composition that Ingres had devoted to this subject in 1827, Rodin began by integrating his group into a tradition closer to the eighteenth-century love scenes of Fragonard and Boucher (*Hercules and Omphala*). The artist represented the figures nude, whereas in Dante's poem (Canto 5), the scene related by the heroine corresponds to the moment when, after reading to her of the loves of Lancelot, her brother-in-law, Paolo, gives her the fateful kiss. *The Kiss*, which depicts two bodies united in an unabashed embrace, was considered an immodest and shocking spectacle when it was exhibited alone at the Salon of 1886, but became a sensation when it was shown in an enlarged version in 1898. From an incidental literary subject, Rodin created a work of a more general scope,

of which Gustave Geffroy wrote: "By the supreme magic of art, the kiss is visible, just barely indicated at the junction of the lips; it is visible not only by the absorbed expression of the faces, but also by the simultaneous thrill that courses through these bodies from the nape to the heels, in each fibre of this manly back, arching, holding still, loving with every part of his body; in this leg which seems to turn gently to brush the leg of his beloved; in the woman's feet barely touching the ground, lifted with her entire being in a flight of ardour and grace."

There is no Paolo any more, and no Francesca, just a man and a woman surprised in their amorous ecstasy. This is what fascinates the spectator: this life, this desire which seems to fill the marble itself. The fame of this sculpture rests on its subject-matter, on its direct erotic imagery, and not on the composition, which Rodin himself admitted was rather conventional. One detail still alludes to its origin: the man holds the Lancelot book in his left hand, recalling the instant when, as Francesca related, "we did not read further on that day".

In the *Gates of Hell*, though, the damned couple is embracing just as Dante described them, "two shades flying together, abandoning themselves to the winds in their wistful course", and as Préault had also seen them. There, the two bodies seem indeed to float, holding on to each other not in any erotic sense, but with a tragic passion, as if afraid of being separated in the infernal realm of the Second Circle: forever united by their desire, the lovers suffer eternally. Paolo's face, which later provided a *Head of Sorrow*, expresses this tormented passion; his halfopen mouth seems to be gasping in anguish. But ambiguous figures do exist: might it not represent the moment of ecstasy instead? This mixture of sensuality and fear is a leitmotif of the *Gates of Hell*. Soon, however, the sensual and amorous figures would proliferate, while the *Burghers* became the outlet for Rodin's ability to express pain.

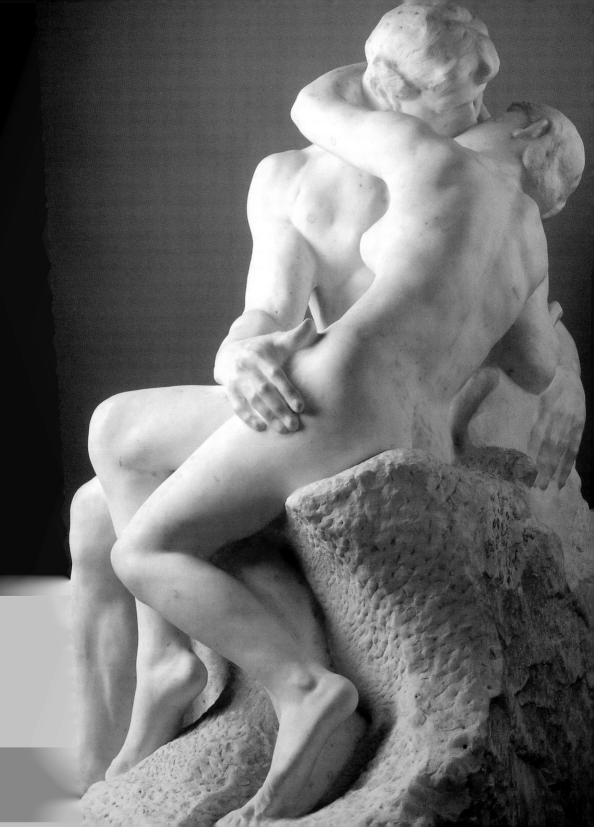

**The Kiss**
*1886-1898, marble,*
*1.386 x 1.105 x 1.183 m.,*
*Paris, Musée Rodin.*

Inspired by Paolo and Francesca's kiss, a scene which
should have appeared on one of the doors; famous for its
realism and forthrightness, this group is nonetheless
very traditionally rendered.

# Fugit Amor

Another version of the windswept couple torn between sensuality and suffering became an independent sculpture with the title *Fugit Amor*. The back-to-back arrangement of the lovers is particularly contorted: the young woman seems about to fly away, her hands on her head, while the man, head thrown back, tries to hold her back in his embrace. Rodin was fascinated by this adolescent figure with straining arms which later became *The Prodigal Son* (1888). He analysed it twenty years later in these terms: "I accentuated the bulge of the muscles to show distress. Here, here, there... I exaggerated the strain of the tendons to mark the impulse of prayer."

The novelist Paul Bourget, in his *Physiology of Modern Love* (1888), used this group to describe the experience of breaking up:

"I have in my rooms in the rue de Varenne, in my souffroir overlooking the gardens which my Colette used to dishonour with her presence, a statue group by Rodin, a fragment from his *Gates of Hell*, which I can never behold without a profound feeling of sadness. In this piece of marble is the symbol of the terrible struggles that mark the end of a love relationship... The woman is nude. Lying on her belly, she arches up in a supreme effort also expressed by her tightly-closed lips, her extended legs, and her hands cramped in her hair. Which effort? The effort to tear herself away from the embrace of the man, who is also nude, lying on the woman's back like a rack, shoulder to shoulder, rump to rump. He, too, would like to tear his flesh from this flesh, but he is enthralled by these beautiful breasts which his crazed fingers hold in a fierce grip. Never, never will he be able to leave this tormenting bosom, and his face expresses something like a gasp of pain. How they hate each other, these two beings - almost as much as they loved each other before! For they did love, almost to the death, as one can see by the exhaustion of their burned-out bodies, by the tremors of their tensed muscles. They would not be engaged in so mad a flight had they not first enjoyed the most wild caresses. And now that their gazes are averted, that their mouths avoid each other, that their souls curse each other, sensuality still holds them fast in its invisible bonds. Ah! how well the sculptor, a disciple of the dark Florentine, succeeded in lending a fearsome poetry to this vulgar final act of the drama of love called breaking-up."

**Fugit Amor**
*Around 1887, marble, 0.51 x 0.72 x 0,389 m.,*
*Paris, Musée Rodin.*

A variation on Paolo and Francesca, in which
the lover desperately tries to hold back his beloved.

# Couples

**The Eternal Idol**
1889, patinated plaster, 0.74 x 0.618 x 0.42 m.,
Paris, Musée Rodin.

Suffering vanishes in favour of sensuality, not to say an almost religious dimension of love, in the statues of couples that Rodin produced by the score in the years between 1880 and 1890. Their titles were *Eternal Springtime* (1884), *Faun and Nymph* (also called *The Minotaur*, around 1886), *The Thrall* (around 1888), *The Eternal Idol* (1889). Rodin seemed to be creating a glossary of delights, including the sapphic loves so dear to Baudelaire. The Dutch critic Willem Bywanck, who visited his studio in 1891, described these groups:

"First there was a lascivious bacchante embracing an old satyr with the utmost wantonness... Then there was a group with a young hero and a woman, called *Springtime*, or *Love*, who stands in his way. She offers herself and all her charms, if only he will take the trouble to desire her... The third group symbolizes the ecstasy of passion: a young man kneeling before his beloved, touches his lips to her belly."

Designed to appeal to the public's appetite for sensual imagery, and therefore more concerned with subject-matter than with formal invention, works like *The Eternal Springtime* and *Fallen Angel* (around 1895), partake of an aesthetic in which the finish and polish of the marble or bronze, and the voluptuous grace of the lines, all contribute to visual delectation. The man kissing the breasts of *The Eternal Idol* is none other than Rodin himself, a sort of latter-day Pygmalion. His cult of female beauty, although transposed into ideal or mythological representations, stemmed from his personal experience and turned into an obsession. "What is the *Thinker* thinking about? About just that", wrote Philip Sollers in a book devoted to the artist's erotic drawings. A somewhat brisk judgement of his art maintains that Rodin himself only had "that" on his mind. Rodin explained more simply: "Art is in fact nothing but sexual delight. It is only a derivative of the power to love." A belief which his love life certainly confirmed.

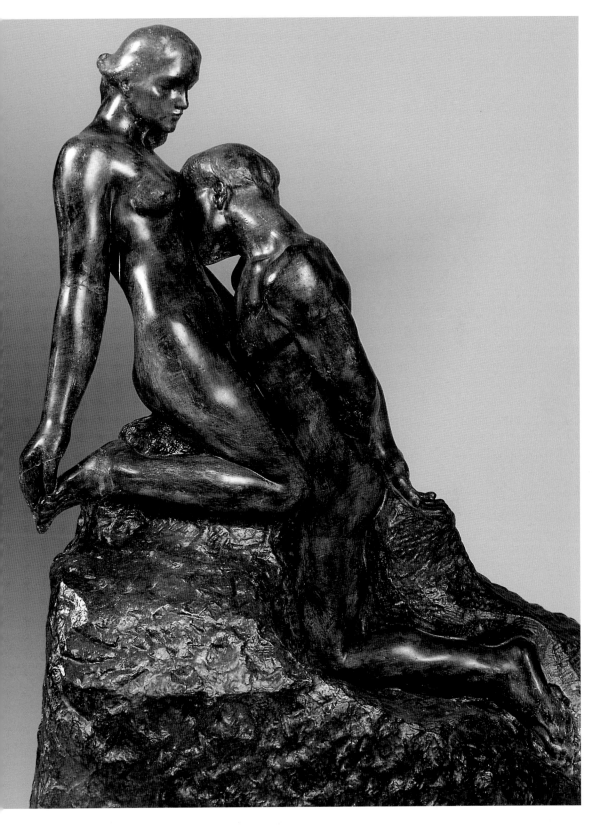

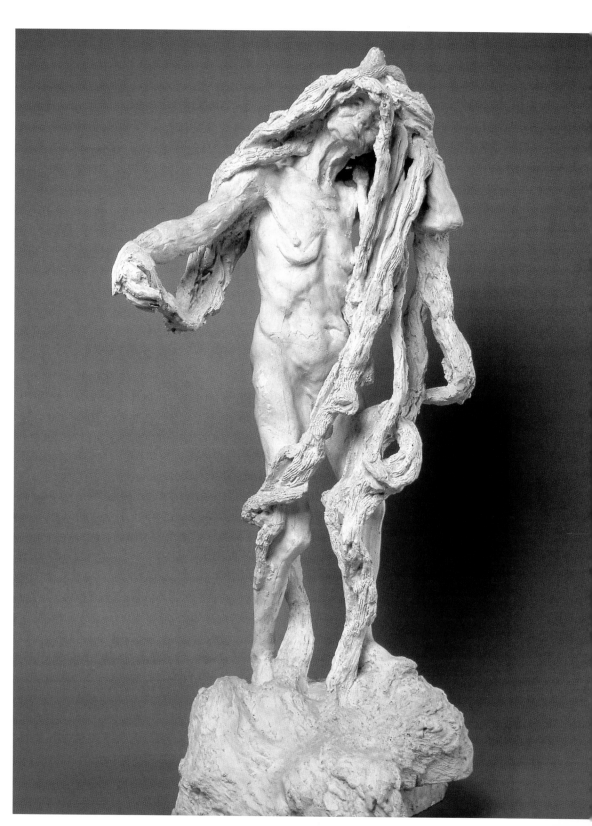

# Camille **Claudel**

Of all the artist's mistresses – and they were legion,
according to his biographers: models, students, aristo-
crats, society women, Englishwomen, Americans, Poles
– only one ever really mattered: Camille Claudel.

Not even Rose Beuret, the woman who played a
primordial role in Rodin's life and in his discovery of
sensuality, who remained for fifty years his faithful
companion and helpmate, and whom he had used as
a model in her youth, could pretend to have had so
strong an impact on Rodin's art as Camille. As for the
Duchess of Choiseul, an American who for eight years
reduced him to playing the part of a mundane, stupid
and vain old man, and although instrumental in intro-
ducing his works in the USA and in attracting awards,
she was only the most lucid and cumbersome of the
intriguing fortune huntresses who took advantage of
his old age. Rodin had other passionate love affairs
besides Camille, he even inspired some which ended
tragically, like the suicide of his student Nuala O'Donel.
Yet only his love for Camille found its way so forcefully
into his own creation. Their relationship was the con-
frontation of two great artists.

His encounter with Camille Claudel took place at a crucial moment in his career, and it occurred at a time when erotic subjects gave a new impulse to his art and began to flourish. Abetted by the context of the *Gates of Hell*, in which Camille's presence was already noticeable (she was the inspiration for *The Danaid*, *Francesca*, *Fugit Amor*, and *The Thrall*), sensual and lascivious images abounded. As it happened, the Couple was also Camille's major theme at the time, though she held back from the sexual frenzy that characterized Rodin's work. A woman, already not too well accepted in the world of sculpture, and of bourgeois birth at that, was in no position to treat these subjects so overtly. The result was a fascinating dialogue between the works of the two lovers expressing their passion and their pain.

Despite detailed research, the precise date of their first meeting remains unknown. Rodin went to the studio that she shared with other young women in the rue Notre-Dame-des-Champs to replace their teacher, Alfred Boucher, who had left for Rome, probably in 1883. He was busy with the *Gates* and the commission for Calais was shortly due. Their final break, after a tempestuous relationship, occurred fifteen years later, in 1898, the year in which his *Balzac* and the monumental version of *The Kiss* were presented. These were thus Rodin's most fertile years.

Born in 1864, Camille was twenty-four years younger than the sculptor when she became his assistant (he never took on students). There is no doubt that she was influenced by him, but she was also able to free herself from it. Thus, her *Clotho* (1893), also called *La Parque*, is related to *La Belle Heaulmière*, but also presents a quite original image of Destiny: the standing figure of the spinner of fates clutches in her deadly hands her long hair mixed with the thread on which human life depends. Beyond the realistic rendition of an emaciated body and the meditation on the precariousness of feminine beauty, this statue gains significance from the fact that it was a young woman who sculpted so dramatic a representation of an elderly woman. Its success was due to the ingenious and stunning treatment of the tangled hair and threads.

In the heyday of their passion, the two lovers shared a studio in a dilapidated eighteenth-century extravagance somewhat out of the way in the 13th arrondissement. Rodin used Camille as model for many works and her services as a collaborator: she is the delicate *Thought* emerging from a block of marble (1886). Before long, however, their relationship took a dramatic turn. In 1892, when she exhibited a striking portrait-bust of Rodin, he represented her in *Farewell*.

What made this relationship so tragic and impossible was Camille's talent and self-awareness, which prevented her, as a woman, from accepting a position like Rose's, and, as an artist, from appearing to be nourished only from the inspiration of the master. She

must have long hoped for Rodin's recognition through marriage. But to no avail; the sculptor was not so smitten by love as to jeopardize his freedom. As her brother, Paul Claudel, bluntly put it: "She staked all she had on Rodin, and she lost everything with him." She became withdrawn, felt persecuted, exploited, and lived in seclusion, alternately creating and destroying her works. In 1913, in the wake of her father's death, she was committed to an asylum by her family, which was eager to put an end to the scandal. She died there in 1943, without ever regaining her lucidity or seeing her fate improved. Her works, with the exception of the few sculptures salvaged by the Musée Rodin, were widely dispersed and mutilated. The bourgeois values of her family, Rodin's fame, and that of her own brother, stifled the flame of an artist who was not only talented, but also very little inclined to compromise with convention.

A number of Camille Claudel's major pieces were linked to the vicissitudes of her relationship with Rodin. Thus, at the Salon of 1888, she exhibited the plaster of *Sakuntala*, or *Abandonment*, a subject drawn from a Hindu legend: "Sakuntala and her husband, separated by a cruel spell, are finally reunited in Nirvana." This piece, which was renamed *Vertumnus and Pomona* in 1905, takes on its full meaning when compared with *The Eternal Idol*, Rodin's painful tension being replaced by a gentle abandon. Other groups, like *The Waltz* (1893), veered completely away from his influence in favour of the contemporary idioms of Art Nouveau. Léon Daudet had the following to say about this sculpture: "The couple, swept up in a frenzied gyration, gives the admirable impression of a dizzying whirlwind, while these handsome nude beings remain locked in their stony embrace." This dynamic and whirling composition is a paean to love; there is still the possibility of ecstasy, even if one may detect in it – as Octave Mirbeau did – the pull of death.

On the other hand, a group like *The Prime of Life* is completely the product of her own experience. A kneeling figure of a young woman –presented at the Salon of 1894 as *God Flown Away*, and in 1905 as *The Implorer*– seems to be pleading with a man being held back by an old woman. One can see it, as did the Inspector of Beaux-Arts Armand Silvestre, as a symbol of man torn between youth and old age; but it patently depicts the artist caught between Rose and Camille. Furthermore, the positions were altered between the plaster of 1894 and the bronze of 1899: the man stands farther away from the woman, their hands no longer touch, and the old woman, a veritable Clotho, clings to him and pulls him away. Indeed, between these two dates, Rodin had definitively broken off with Camille. To parry Rodin's sway, she devoted herself to minor scenes of everyday life, far removed from the voluptuous imagery of the master. Rodin resumed his turbulent love-life, while Camille sank into a world of solitude, misery and madness.

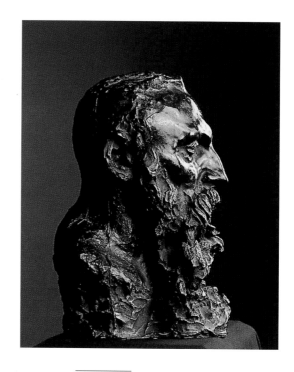

**CAMILLE CLAUDEL**
**Portrait of Rodin**
*1888, bronze, 0.407 x 0.257 x 0.28 m.,*
*Paris, Musée Rodin.*

Exhibited at the Salon of 1892, Rodin called this
bust "the finest sculpted head since Donatello".

**CAMILLE CLAUDEL**
**The Prime of Life**
*First version, 1894–5, plaster,*
*0.87 x 0.995 x 0.525 m.,*
*Paris, Musée Rodin.*

This work has two layers of meaning: universal –
man between youth and old age – and personal –
Camille being abandoned by Rodin held in the
clutches of Rose Beuret.

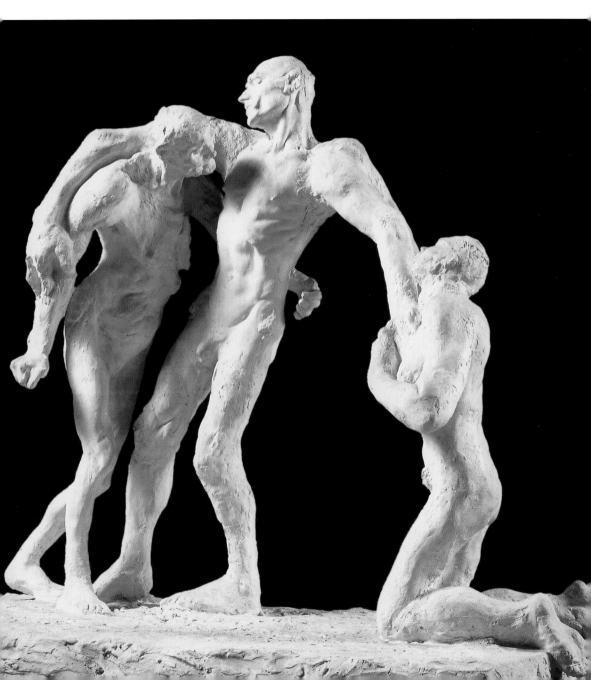

# The cult of the body

Let us leave aside the often sordid intrigues which contributed to turning Rodin into a "priapatriarch", to quote Paul Claudel's term. What counts is the extraordinary relationships he had with women, the power of his obsession, which grew to such an unbounded degree thet it became a positive hindrance to his best friends who had young daugthers or to women who wanted to deal with him only as the sculptor and not as the man. Some society women recounted sittings which very nearly bordered on rape. The dancer Isadora Duncan may later have regretted not having sacrificed her virginitty to the great creator, but not a few women walked out and left their busts unfinished.

Rodin took as much pleasure in handling a woman's body as he did in modelling the clay. He had a compulsive need to be surrounded by naked women. The sessions in his studio in the Hôtel de Biron were a combination of work and orgies. The models were free to walk around naked while Rodin watched for a pose or position which he deemed worthy of being set down on paper or in stone. In this way, countless clay sketches

**Embracing Couple from the Circle of Loves**

*Around 1889, graphite, pen and ink, and bistre wash on buff paper mounted on ruled paper, 0.162 x 0.102 m., Paris, Musée Rodin.*

l'amour profond comme les tombeaux Baudelaire

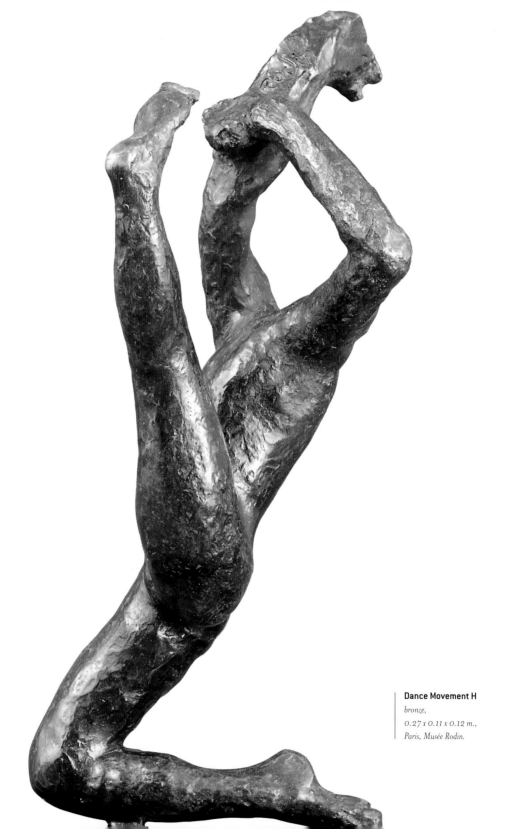

**Dance Movement H**
*bronze,*
*0.27 x 0.11 x 0.12 m.,*
*Paris, Musée Rodin.*

came into being, figurines with bold forms, quick nota-tions of a movement which the sculptor would keep, re-work or destroy to begin anew. His studio was full of figures, more often than not fragmentary, heads and limbs that he then worked into different combina-tions. These sculpted sketches seem to hark back to the art ot Antiquity. Displayed in the showcases at his house in Meudon, these figurines are sometimes difficult to distinguish from the actual ancient Greek works mutilated by the passage of time.

Some of the most famous and earliest of these figures were given titles. *Iris, Messenger of the Gods* and *Flying Figure* (around 1890) both display the widely spread legs that were to become a leitmotif of the figurines of dancers. Invariably, the disposition of the limbs served to create bold arabesques or forms. He was especially fond of working with a model who was so supple that she could take on the poses of a contortionist. He kept these figurines hidden in a cabinet which his detractors soon referred to as his secret erotic museum. Yet these nudes were not very much more immodest than most of his works.

Marcelle Tirel relates how, in 1916, when the Rodin donation was officially signed, the senators and administrators asked to see this secret museum in the hopes of some additional titillation.

Drawing was to be the focus of Rodin's last efforts. When searching for a subject, he had always made drawings and he had learned engraving from his friend Legros in London. Using studies that bore no relation to the texts, he illustrated two literary mas-terpieces, *Fleurs du mal* published by Paul Gallimard in 1887-88, and Octave Mirbeau's *Jardin des supplices* (*The Torture Garden*) in 1902, at the request of Ambroise Vollard. One hundred and forty-four draw-ings selected by his friend Maurice Fenaille, art historian and patron of the arts, were published by Goupil in 1897. In his old age, he turned out thousands of drawings, nearly all devoted to female nudes and cathedral architecture. What greater formal and the-matic contrast than between these two series? On the one hand, painstaking drawings of architecture, and on the other, drawings of nudes made with a breathtaking verve and spontaneity.

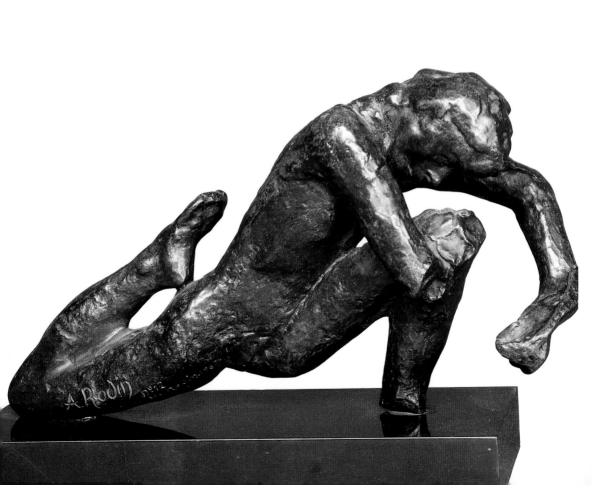

Previous pages:
**Cambodian Dancer**
*Standing on the right leg with her left hand on her hip, July 1906,*
*graphite, gouache, and touch-ups with black pencil on buff paper,*
*0.321 x 0.246 m.,*
*Paris, Musée Rodin.*

**Dance Movements**
*Around 1910, bronze, Paris,*
*Musée Rodin.*

**Reclining woman, hand between
her legs, with a bird**
(Leda and the Swan?) *Around 1910, graphite,*
*stump and watercolour on buff paper, 0.323 x 0.249 m.,*
*Paris, Musée Rodin.*

Executed by the hundreds, this drawings of nudes
created the image of a Rodin obsessed with the
representation of female sexuality.

**Female Nude with Long Hair
Leaning Backward**

*Graphite and watercolour on cut-out buff paper,
0.275 x 0.214 m.,
Paris, Musée Rodin.*

The technique of cutting out a drawn figure and pasting
it on another sheet of a different colour created
a contrast effect which set off the play of contours
and unmodulated washes.

Gustave Kahn left an account of how the artist drew: "When he takes notes (as in his wonderful and endless series of drawings), it may happen that he asks the model to make a gesture glimpsed in his imagination, but this is rarely the case. Usually, almost always, the model (female) is free. She can sit, stand, lie down, stretch and, according to her fancy or fatigue, propose a movement, an attitude, a letting go, and one of these images will be stopped by Rodin and captured in a drawing that seems to emerge almost instantaneously. Sometimes he does not even make her stop, but makes a cursive notation, for the rare movement he seeks is a transition between two movements... This series of drawings furnishes him with an encyclopedia of human movements. Are these completed notations ready for immediate use? Not at all. What these indications all lack is scope. The huge sketchbook consulted by the artist takes on full meaning when he seeks the confirmation of a freshly-sprouted idea. The simplest movement, or the observation of a physical attitude can give rise to an idea too."

Rodin's drawings are characterized by an extreme simplicity and modernity. The line flows continuously, without pentimento, shadow or modulation, while dabs of wash create a volumetric effect. He even used forms that he would cut out and paste together. It is impossible not to think of the nudes of Matisse and Gustav Klimt, whom Rodin met in Vienna.

Not surprisingly, like Degas, Toulouse-Lautrec, and Matisse, he was fascinated by the dance, for dancers could show him unusual movements and glimpses of femininity. He became a friend of Loïe Fuller, the Japanese dancer Hanako, and the chahuteuses of Montmartre. He also frequented Isidora Duncan's academy to make drawings. The common feature of all the dancers that caught his attention, whether they were from the Ballets Russes or in a dance hall, was their questioning of conventions through their art. He was not interested in the codified movements of the classical ballet, but preferred the illuminated veil dances of Loïe Fuller, Isidora Duncan's choreographic revivals of the ancient Greek era, the excesses of the French Cancan, the quadrilles with their leaps, splits, feet flung high behind the head, etc. All of them sought to free the body from its traditional constraints and Rodin himself executed

a series of "dance movements", small statues about 30 cm high, in which he captured the essence of the movements. To accomplish this, he eliminated all spurious details, at times leaving the sculptures incomplete, reduced to pure line, when he did not deform them outright for the sake of plastic beauty.

When he discovered the Cambodian dancers of King Sisowath, he followed the troupe to the colonial exposition in Marseilles (1906) in order to be able to continue marvelling at "their singular beauty and the noble character of their dance". His encounter with these dancers confirmed his assimilation of art with religious ritual – "These dances are religious because they are artistic; their rhythm is a ritual" – and he ended up calling the Angel of Chartres a Cambodian figure. Similarly, the young Cambodian dancers reminded him of Greek *Victories*.

Following pages:
**Loïe Fuller Dancing in a Garden**
*Photograph by Harry C. Ellis,*
*Paris, Musée Rodin.*

**Cambodian Dancer**
*July 1906, graphite, watercolour, and gouache*
*on buff paper, 0.32 x 0.245 m.,*
*Paris, Musée Rodin.*

# Sculptures
## in public places

For a poor artist without connexions, without support, as Rodin was until his fortieth year, the only possibility of getting commissions was through contests. Commissions from the State went mostly to artists who had earned prizes at the Salon, or to students of the École des Beaux Arts. This left only public commissions from municipalities or associations founded to raise a monument to some eminence or local hero. But even there, the influence of the academicians and of the professional system had a say in the matter: the juries often included members of the Institute and official artists who had cornered the market for their students and friends. As for the officials and scholars appointed to the juries, they were not often prepared to invest their confidence in artists who had not received official recognition, nor to opt for solutions that departed from academic principles. Finally, participating in contests was an expensive venture, for models had to be made without hope of monetary gain; at best, prizes were sometimes awarded to those who made the best showing.

Bravely, Rodin had tried to gain recognition by this route at the beginning of his career. Until the age of forty, he participated repeatedly and unsuccessfully in these contests. When he finally became known, he received many commissions for monuments, almost all dedicated to artists. Few of these projects were ever completed, and those that were finished became the object of sharp controversy. Rodin's reputation was never a guarantee against criticism, on the contrary. We are thus faced with the almost paradoxical situation of the most revolutionary artist of his time – on the aesthetic level, that is – venturing time and again into the official and barren field of monumental commemorative sculpture. *The Claude Gellée* in Nancy, the *Sarmiento* monument in Buenos-Aires, the *Balzac*, and the *Victor Hugo* all resulted in considerable problems. Only the *Burghers of Calais*, which had its difficulties too, may be considered an outright success, for the organizers, once a number of modifications had been made, finally accepted that the sculptor should be the final arbiter.

As it happened, the men who were daring enough to give Rodin their support were administrators from the Ministère des Beaux-Arts: Edmond Turquet, Antonin Proust, Roger Marx, and Dujardin-Beaumetz. The Institute, on the other hand, became an enduring enemy – only to invite him to join the academic ranks at the end of his life, in 1917.

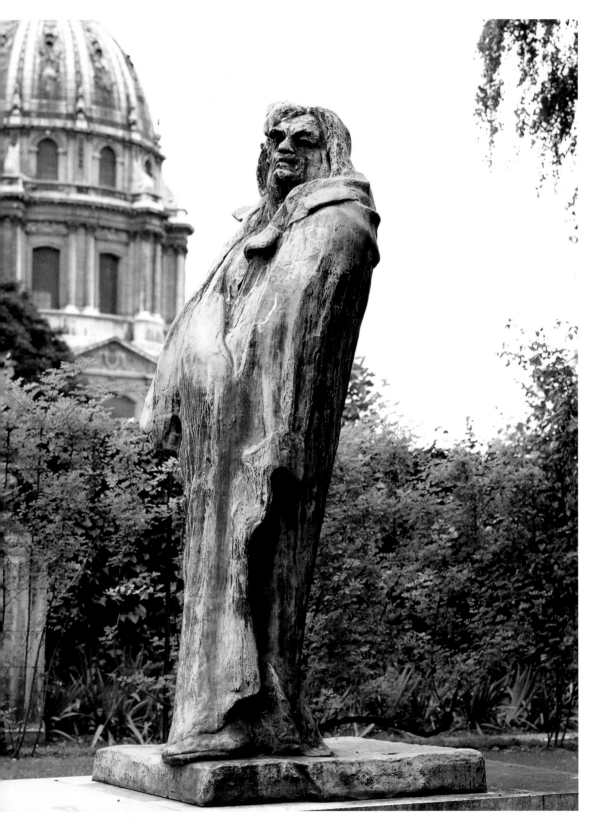

# Failures and
## unfinished monuments

When he decided to stop sidelining as a decorator, Rodin began participating in contests. Thus in 1877, he broke off his partnership with Van Rasbourg, a Belgian, exhibited *The Age of Bronze*, and took part in a contest to raise a monument to Byron at the initiative of a group of English writers, including the Prime Minister and novelist Benjamin Disraeli. Nothing remains of this project today. His model for a monument to the Defence of Paris, *The Call to Arms*, was turned down in 1879, only to resurface in 1922 as a Victory monument offered by the Netherlands to commemorate the site of the heroic defence of Verdun.

Rodin's rejection was due not only to his lack of connexions but also to the masters he emulated. François Rude (1784-1855) had caused scandals with the vigorous expressivity and movement of his groups; his defiance persisted during the Third Republic, which saw the triumph of academicism. Rodin, incapable of subscribing to the fashionable clichés of the day, studied Rude's work closely. The violence of the group in *The Call to Arms*, the overall thrust, and the cry and gesture of the figure of the Republic in a Phrygian cap

were all borrowings from Rude's *Departure of the Volunteers* (*Marseillaise*). He followed the same example in 1884 when he submitted a model for a monument to General Margueritte, whose fatal charge at Sedan had wrung from Wilhelm I these famous words: "Ah! these brave people!" Rodin borrowed the pose from a statue of the Waterloo hero Marshall Ney.

In some cases, circumstances forced the projects to be cancelled. What sculptor did not dream of creating an equestrian statue? Not so much to rival with Verrocchio's *Colleone* or Girardon's *Louis XIV*, as to tackle one of the greatest tests of technical mastery. Thanks to the Vicunas, Chilean friends in official positions in Paris, Rodin was entrusted with the project for an equestrian monument to General Lynch, who had successfully led his countrymen against Peru. The political situation in Chile, however, prevented it from ever being completed. The same thing happened with the monument to the Chilean politician and writer, Vicuna Mackenna (1886).

Another cause of difficulty seems to have been the sculptor himself: faced with commissions for a

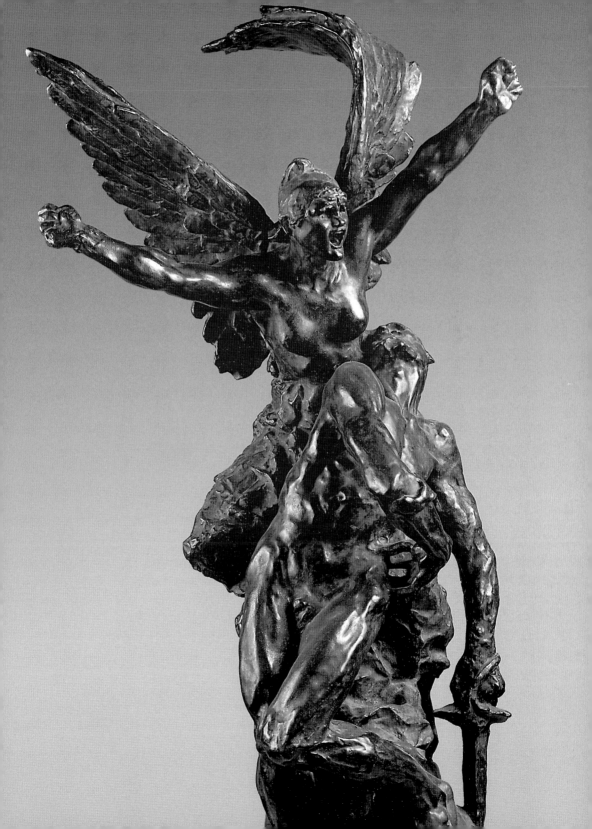

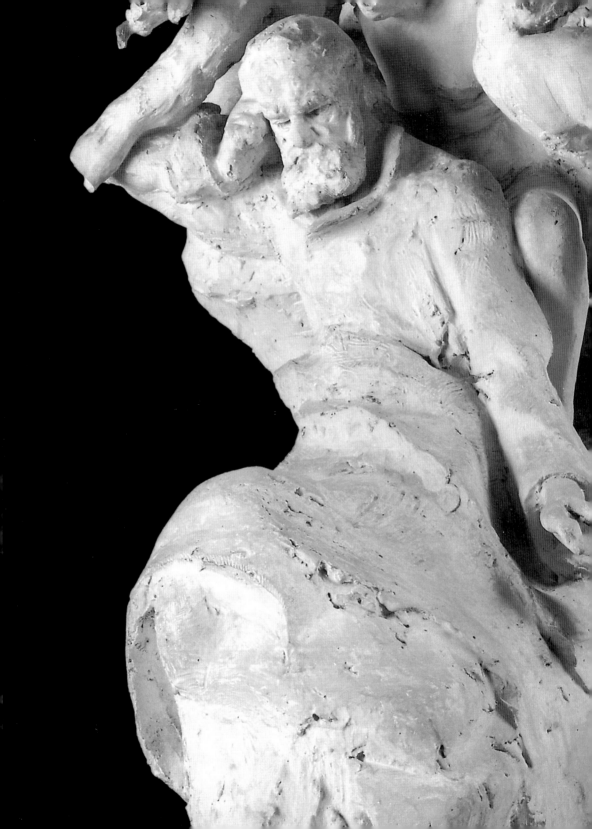

**Monument to Victor Hugo**
*1886–1890, plaster, 0.845 x 0.57 x 0.63 m.,*
*Meudon, Musée Rodin.*

Second model, showing the poet draped and surrounded
by muses in a rather confusing composition.

The Kiss
(detail)
*1886, bronze,*
*Paris, jardin des Tuileries*

memorial, he was hard put to bridle his imagination and think in terms of a monumentality. This was a problem which had sometimes bothered him and it had soon become evident in his work as a sculptor that he was better at making the statuettes, or the scale-models, than the monument itself. In some cases, the concepts of some of the monuments were banal and academic; in others, the composition was so complex as to defy realization. The conflicts that pitted Rodin against his public – and himself – in works like the Balzac, manifested themselves with his very first commissions. There was a lasting problem between the requirements of working on a monumental scale, integrating the monuments in a public space, and the sculptor's concern for expressivity.

How many of these statues, although commissioned by admirers, were never to see the light of day? There were those of his friends Puvis de Chavannes (1824-98) and Whistler (1834-1903). The monument he wanted to dedicate to Eugène Carrière with the help of Desbois remained as a plaster that bears analogies with his projects for the Victor Hugo: a male figure in the company of a hovering muse. The

kinship between Carrière's work and certain marbles by Rodin is unquestionable: the painter wrapped his intimist subjects in a sort of haze or sfumato which Rodin sometimes asked his assistants to reproduce in marble. The best example of this is *A Mother and her Dying Daughter* from 1908, which was inspired by one of Carrière's favourite subjects: all that emerge from the block of marble are the almost imperceptible polished faces and hands. Baudelaire, whose spirit was so prevalent in the *Gates*, did not inspire him any the more for all that. A commission in 1892 resulted only in a very unconvincing portrait head; the subscription committee was subsequently unable to raise sufficient funds to complete the project.

If the poet of *Neuroses* (*Névroses*), Maurice Rollinat, who committed suicide in 1903, was given a monument in his hometown, Fresselines, it was because Rodin revamped an existing composition, *The Morning Star*, or *Before the Shipwreck*, which was rechristened *The Last Vision* to bring it into harmony with Rollinat's style. Not only that, but this bas-relief itself was the product of an earlier assemblage of older pieces, including a head of Saint John the Baptist.

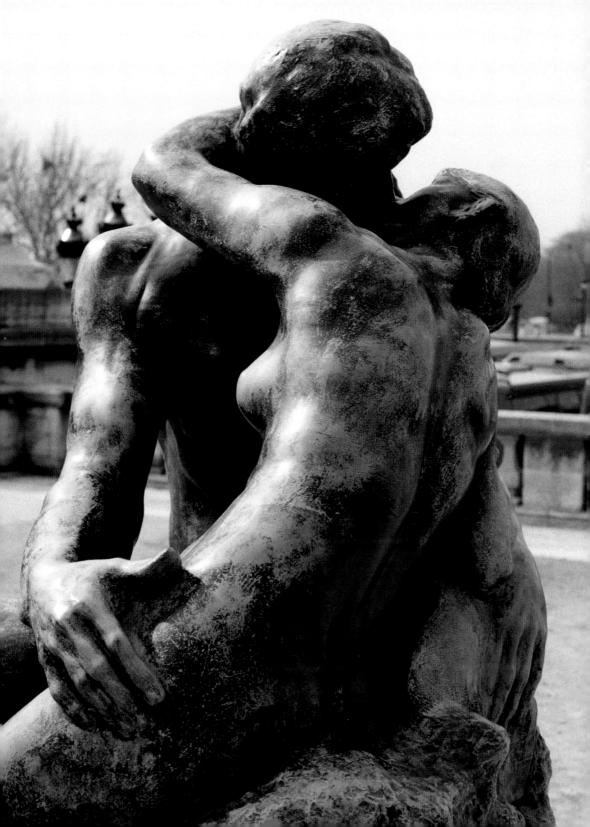

**Jules Bastien-Lepage**
*1887, plaster, 1.76 x 0.875 x 0.88 m.,*
*Paris, Musée Rodin.*

This statue shocked critics because of the coarseness of the costume and pose, through which Rodin had tried to render the painter's wonder in the presence of nature.

# Air and light :

## Bastien-Lepage and Le Lorrain

By some coincidence, the first two monuments that Rodin had the pleasure of seeing unveiled were dedicated to painters concerned with two of the prime elements of monumental sculpture: air and light, an effect that was tempting to recreate. One was raised to the memory of Jules Bastien Lepage (1841-84), in Damvillers, a village in the Meuse Valley, and the other to Claude Gellée, also called Le Lorrain, in Nancy. The first monument, which had been entrusted to him without difficulty, was greeted with the kind of objections that were forever to plague the artist: too little resemblance and an unconventional pose. Rodin chose to represent Bastien-Lepage in rural costume, going out to paint, because his 1877 picture *Haymaking* had earned him a leading position in the

"plein air" school of painting. Shortly before the inauguration of the Bastien-Lepage memorial on 29 September 1889 in the presence of Roger Marx, and thanks to the latter, who was from Nancy, Rodin was awarded the commission for a statue of Claude Gellée (1600-82) after a restricted contest in which he came ahead of Falguière. He proposed a statue of the painter standing with his palette on an allegorical pedestal representing "the Genius of the painter of light". Rodin wanted to create a monument in harmony with the seventeenth-century art that had so deeply marked the capital of Lorraine. In the comments that he submitted with his model, he explained: "In the figure of Claude Gellée wrapped in air and light, I want to express his appreciative attention to the nature that was all around him." As for the pedestal, he wanted it to be a celebration of the "Apotheosis of Light" in the form of the chariot of Apollo. This idea led him to ask his assistants to carve the stone with an eye to recreating the soft atmosphere of sunrise; but when objections ensued, he had the horses recarved.

# H The statues of Victor
# Hugo

Following page:
**Monument to Victor Hugo**
*1909, marble, 1.55 x 2.54 x 1.10 m.,*
*Paris, Musée Rodin.*

After much hesitation, Rodin submitted
a monument which could not be used in
the Pantheon; it was installed in the garden
of the Palais-Royal, then later transferred
to the gardens of the museum. The absence
of the muses accentuates the power and solitude
of the exiled poet.

The difficulties encountered with his *Victor Hugo*
from its inception in 1889 to its inauguration in 1909,
led to the creation of two statue groups and an untold
number of sketches and assemblages. While Hugo
was still alive, Rodin had been permitted to sculpt his
portrait-bust, but only on the condition that the writer
did not have to pose and that the sculptor keep a low
profile. Determined to produce a figure as famous as
the sitter, and thanks to his memory and drawings
sketched on the sly, in 1883 he was able to create a
work that could be used after the poet's death as a
monument to his glory.

On September 16, 1889, in a clear gesture of offi-
cial recognition, the State commissioned Rodin to
execute a *Victor Hugo* destined for the Pantheon, which
was finally being used as the mausoleum it had been
designed to be. The statue was supposed to have been

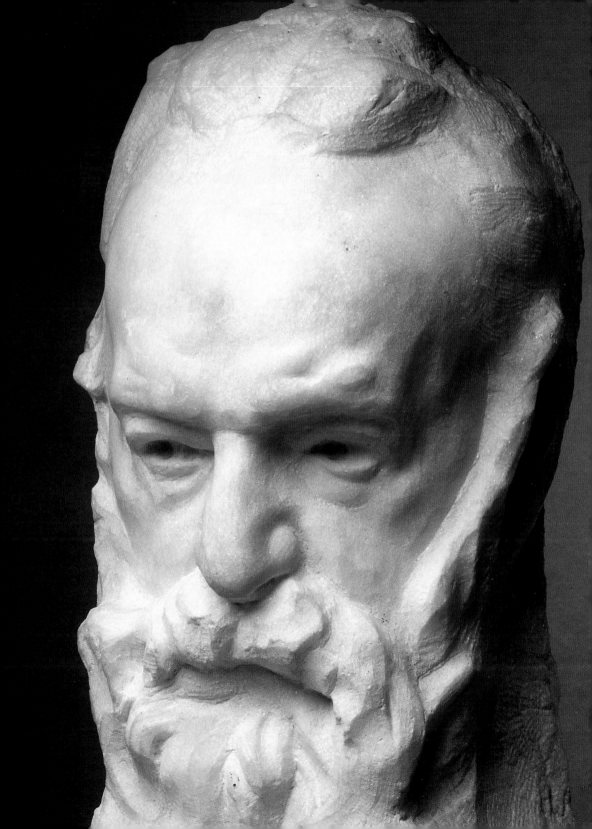

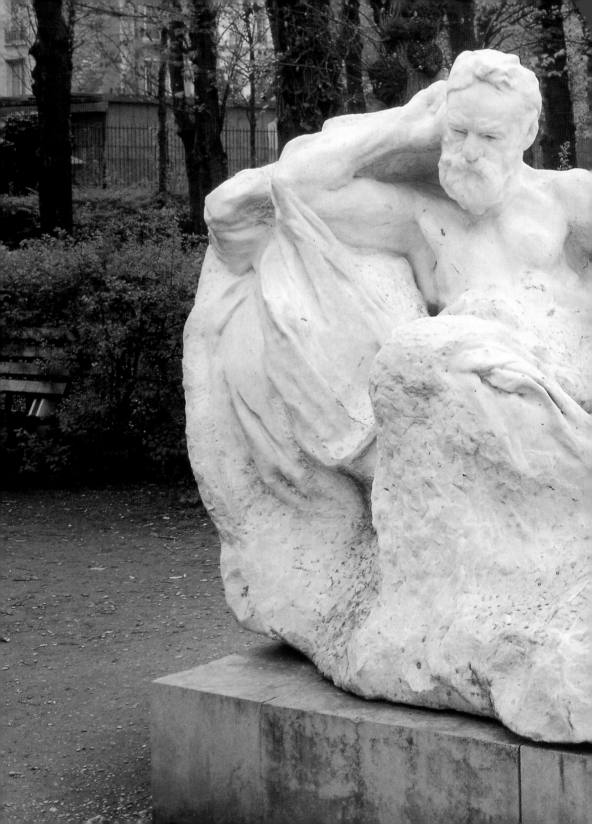

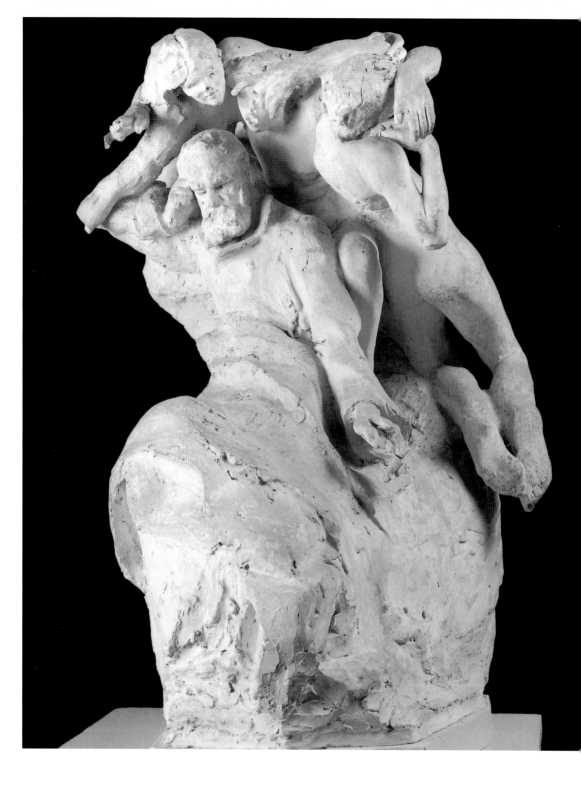

**Monument to Victor Hugo**
*1886-1890, plaster, 0.845 x 0.57 x 0.63 m.,*
*Meudon, Musée Rodin.*

integrated into a composition designed by Gustave Larroumet, Directeur des Beaux-Arts, and to be placed in the north transept as a pendant to the *Mirabeau* entrusted to Anton in Injalbert (1845-1933) in the south transept. The will to make the transformation of the edifice a reality was demonstrated by the fact that 150,000 of the annual budget of 600,000 francs devoted to decoration work was allocated to these two projects.

Informed unofficially as early as 1886, Rodin sketched a group showing the poet listening to his Muses. His definitive pose was quickly established: the poet in centemporary dress sits on a rock that evokes his exile on the island of Guernsey. Soon, however, returning to the classical tradition of heroic statues, he proposed a nude Victor Hugo which proved offensive to the taste of the supervisory committee. Stylistic fashions had changed over the previous few decades; Neoclassicism was out and the use of contemporary costumes was in. Robert de la Sizeranne, who wrote on the subject of 'modern dress in statuary' (1904), took precisely this *Victor Hugo* to demonstrate that contemporary costumes were an artificial form of modernity and that Rodin had endowed his nude with a monumentality and an intensity that perfectly expressed Hugo's "meditative and imperious" nature.

As for the Muses, their identity and disposition were subject to transformation: first there were muses of Youth, the Prime of Life, and Old Age hovering in a sort of whirlwind above the venerated head. These were changed into *Les Châtiments*, *Les Contemplations*, and *Les Voix intérieures*, the titles of three books of poetry by Hugo. They were then reduced to two figures, one symbolizing the *Tragic Muse* and the other *The Inner Voice* (also called *Meditation*), still in reference to Hugo's works. On the grounds that the figure had to be standing to match the *Mirabeau*, and harping on its "confused forms", the committee rejected the model. Gustave Larroumet saved the monument by suggesting that it be placed in the Luxembourg Gardens and that Rodin design another *Hugo* for the Pantheon. In the end, the reticence of the officials and Rodin's own

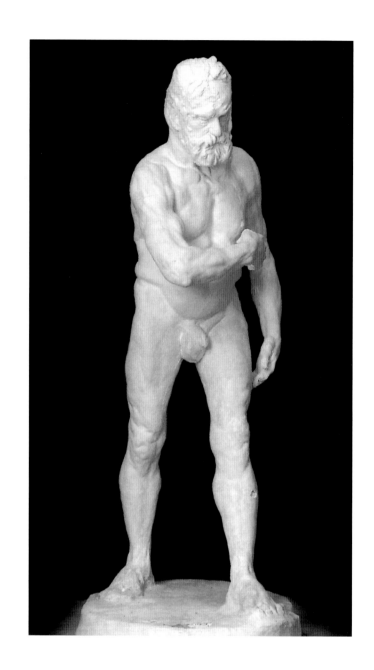

**Monument to Victor Hugo**
**Victor Hugo Standing**
*1893, plaster, 2.23 x 0.964 x 1.405 m.,*
*Meudon, Musée Rodin.*

doubts led to a double commission, only one of which was ever completed. Thanks to Dujardin-Beaumetz, the seated *Victor Hugo*, without Muses, was executed in marble and solemnly installed in the gardens of the Palais-Royal on December 30, 1909.

As for the Pantheon group, Rodin wrote to Larroumet on December 8, 1890: "I am working on the apotheosis, since that is what is written on the pediment, To Great Men, a Grateful Nation. Victor Hugo is being crowned by the genius of the 19th century, an Iris leaning on a cloud also crowns him, or rather their hands join, holding flowers and laurels above him. Below this, I am creating a powerful figure with head raised, contemplating the poet's apotheosis. This represents the crowds that celebrated his unforgettable funeral, all of us, the *vox populi*. Victor Hugo is on the rock, waves break against the rock, and a Nereid or a wave transformed into a female body brings him a lyre. Behind the monument, Envy runs away and hides in a crevice."

Rodin's submissiveness and his desire to provide a project satisfactory to the administration are astonishing: the rebel came up with a project full of props and a complex allegorical programme. For sure, this composition had everything to harmonize it with the neo-baroque works of Injalbert. But once his sketches had been submitted, and after much hesitation on the position of the nymphs and muses, and on Hugo's costume, the sculptor dropped this project. This was at a time when he had no lack of official support: *The Thinker* was installed in front of the Pantheon in 1906, and he received a commission for a version of the *Burghers of Calais* for this same national shrine (a bronze of Jean d'Aire stood in the Pantheon from 1911 until 1915). But all of these were earlier works; his new ideas were either too revolutionary to be accepted, or too conventional to retain his interest for long! And although his reputation had spread and consolidated his position, this was not enough to win broad approval for his aesthetics. Consequently he eventually stopped courting this kind of commission.

# The Balzac
## affair

At the same time as the controversy over his *Victor Hugo*, fate served the artist with another, even more cruel conflict and rebuff. *The Burghers of Calais* and *Balzac* were Rodin's main achievements in the field of "plein air" (outdoor) sculpture. The *Balzac* project launched the sculptor into an unending series of experiments which disconcerted his patrons and even some of his supporters by their modernity.

Founded in 1837 to protect authors' rights, then still largely violated, the Société des Gens de Lettres de France had long wanted to erect a monument to Balzac, its second president. The project was first entrusted to Henri Chapu. Upon the latter's death in April 1891, Émile Zola, the incumbent president and an admirer of Rodin, acted swiftly to transfer the commission to Rodin by July of that same year. The sculptor agreed to execute a statue measuring at least three metres high and to be delivered on May 1, 1893, for the sum of 30,000 francs. This was an invitation to just the kind of problems with which Rodin was by then all-too familiar.

He nonetheless threw himself enthusiastically into the project, immersing himself in Balzac's life and work. He proceeded exactly like a natural scientist, visiting the novelist's beloved Touraine, studying the physical types specific to this region, and would have plunged even more deeply had Gustave Geffroy not reminded him of the writer's southern origin. He even tracked down Balzac's tailor to find out his measurements and to have clothing made to these specifications. He collected all the known portraits, lithographs, dagguereotypes, medallions, and Louis Boulanger's painting. Yet when the deadline for presenting a model rolled around in November 1891, Rodin still had nothing to show. However, when he finally did come through, the society's committee approved his project, appreciating his realistic approach and his refusal to idealize the novelist, who was usually represented as a colossus with a big mane of hair.

Hesitating between the nude – a cause of much controversy in the *Victor Hugo* project – and drapery, the sculptor finally adopted Chapu's solution by representing the author in the monk's cowl that he liked to affect. Rodin even went so far as to have a housecoat made in Balzac's size and then had it soaked in plaster! He laboured without let-up, executing a clay or plaster bust after almost each portrait or caricature of Balzac. In their book *Auguste Rodin*, Robert Descharnes and Jean-François Chabrun made an interesting comparative study of the sculpted sketches and the original source documents. The determination of the figure's outline was also an occasion for endless trials: nudes, the legs spread apart or brought together, with frock-coat, housecoat, etc... The year 1893 came around without any definitive solution having been found. And when the committee realized that Rodin was deviating from the realistic approach and proposing instead an interpretation, not of the man, but of the legendary creator of the *Human Comedy*, the members made their fears and hostility clearly known. Despite the support of Zola's successor, Jean Aicard, who obtained an extension in 1894, a first round of controversy broke out and the *Balzac* was dismissed as a 'colossal foetus'. Court action was taken against Rodin, who had to return his 10,000 franc allowance to a notary until he finally delivered the promised project. Outraged, Aicard resigned.

The *Balzac* played no small part in establishing Rodin's reputation as an artist who "too often courted catastrophe", as Anatole France put it, and who slowly destroyed his works through dissatisfaction, or, as some said, his inability to finish. The next president of the Société des Gens de Lettres, society columnist Aurélien Scholl (1833-1902), at first demonstrated patience and understanding for the creator's high standards, but in 1896 he finally asked him to renounce the project. "Rodin", he wrote, "is the genial creator of the *Gates of Hell* and of a dozen other

**Copy of Balzac's Dressing Gown**
*Around 1895, cloth soaked in plaster,*
*1.45 x 0.575 x 0.42 m., Meudon, Musée Rodin.*

Made according to Balzac's measurements,
this empty garment provided Rodin
with the essential form and character
of his statue.

Following pages:
**Monumental Head of Balzac**
*Enamelled stoneware, 0,422 x 0.446 x 0.382 m.,*
*Paris, Musée Rodin.*

**Balzac in a Dominican Habit**
*1892–1895, plaster, 1.08 x 0.537 x 0.383 m.,*
*Paris, Musée Rodin.*

**Balzac, Nude Study C**
*1893–5, bronze, 1.27 x 0.56 x 0.622 m.,*
*Paris, Musée Rodin.*

masterpieces, but the statue of Balzac is beyond his powers in the same way that a five-act play was beyond Balzac's powers." Rodin let the sarcasms fly and ventured a showdown only in 1897. In the meantime, he had modified the work, dropped the pose with the legs spread, and tried a more static pose with clothing, the body arched and topped by a massive head with hollow eye-sockets and a jutting chin; in other words, the synthesis of the heads elaborated over the previous ten years. He decided to exhibit a half-lifesize model at the Salon of the Société Nationale in 1898.

It unleashed a fury that was expressed in a variety of epithets aimed at the *Balzac*: "snowman", "colossal clown", "menhir", "unwrapped statue", and at the artist, dubbed "Michelangelo of the goitre". According to Jean Lorrain, Henri Rochefort commented: "Never before had it occurred to anyone to extract a man's brains and throw them in his face." This lack of comprehension was understandable in the context of the Salon, and not even Rodin was surprised. To make matters worse, a large marble version of *The Kiss* was exhibited right next to the *Balzac*.

A comparison of these two works elucidates the state his work has reached around 1900. The sculptor himself pointed out this parallel on the day the two works were being transported to the Salon. As he told Camille Mauclair: "I was not displeased with the simplified vigour of my marble. When it passed by, however, I had the impression that it was soft, that it collapsed next to the other … and I felt in my soul that I was in the right, even if I was alone against all the others." Indeed, what greater contrast than between these two works? *The Kiss* not only had its crowd-pleasing erotic subject in its favour, but also its realism and a traditional, polished handling. The *Balzac* next to it stood out as a fierceidol that displayed no concern whatsoever for the all-important likeness, and with a formal simplification that stressed its monstrous mass. And yet it was the future of sculpture that was in play – just as it had been a few years earlier with the *Burghers* – and not his aesthetically insignificant evocations of sensual love, no matter how fascinating and powerfully rendered. A number of artists and critics, however, saw the light. Bourdelle exclaimed that Rodin was leading the way, while others

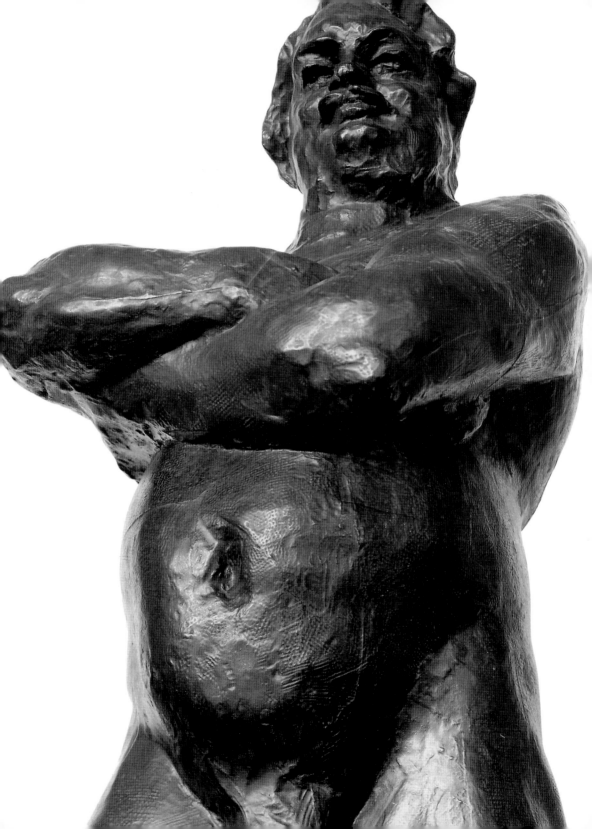

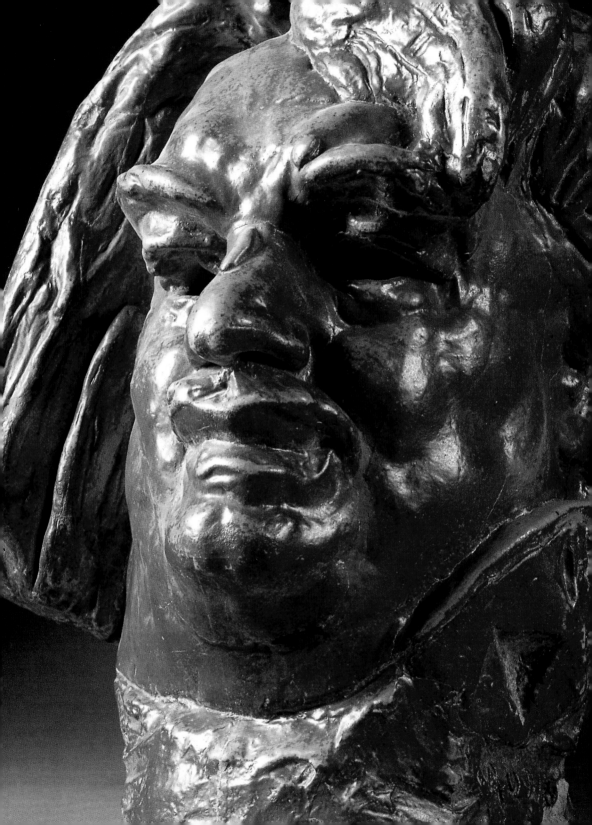

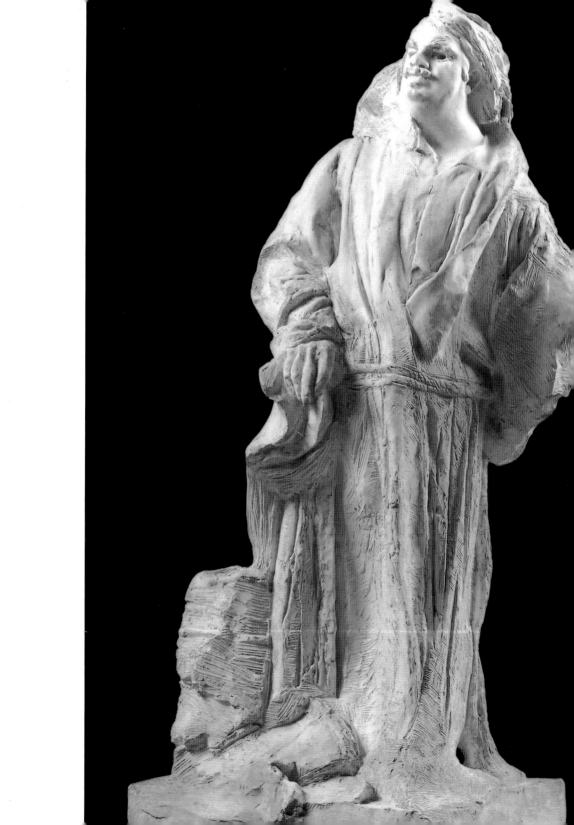

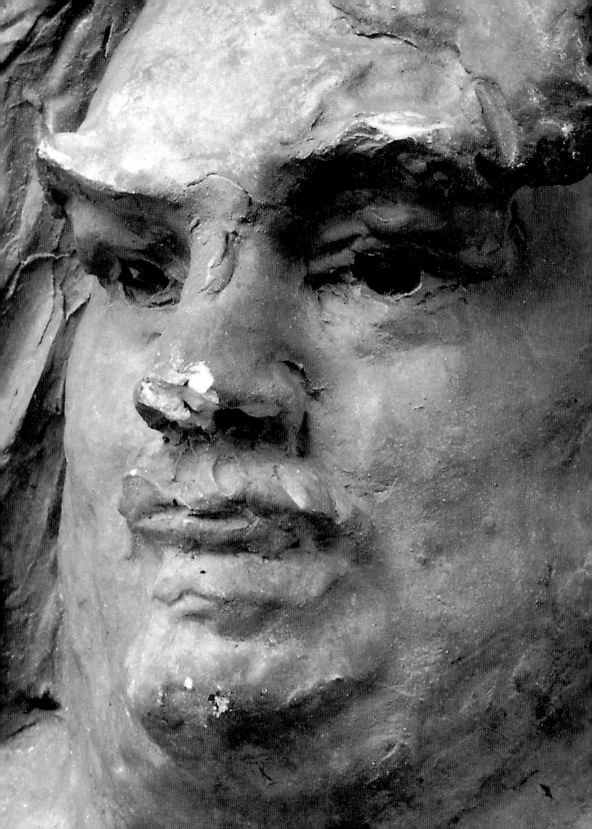

**Balzac,**
*Studies for the Head,*
*1891–1895, terracotta,*
*Paris, Musée Rodin.*

said that he had successfully expressed Balzac's awe-some genius. But the commission of the Société des Gens de Lettres, backed by public opinion, refused to "recognize the statue of Balzac" in the proposed model and cancelled the contract. The sculptor was forced to return the sums already paid out. Rodin's friends, Mirbeau, Geffroy, Carrière, the journalist Mathias Morhardt, and the young writer Georges Lecomte, then circulated a petition and organized a suscription which raised the 30,000 francs needed to produce the statue; but Rodin rejected this solution on the grounds that this was compromising with the dreyfusards. For the debate around the *Balzac* was taking place against the backdrop of the Dreyfus Case and most of the signa-tures came from defenders of Dreyfus who had also signed the petition supporting Zola after his conviction for publishing *J'accuse*. Rodin had denied Zola his sup-port on the grounds of indifference, claiming that his only passion was the future of art. The truth is that, privately, he was an antisemite, and therefore anti-Dreyfus. He further rejected the offers of two wealthy art patrons, and the statue was hauled away to the Villa des Brillants, the house in Meudon that he had bought in 1895. The Société des Gens de Lettres subsequently turned to Falguière for their memorial. By the Salon of 1899, this sculptor had finished a figure of Balzac seated and dressed in a housecoat. Rodin, letting bygones be bygones, exchanged busts with Falguière and, when his colleague died in 1900, even helped prepare the posthumous inauguration of his seated *Balzac*.

The supporters of Rodin's *Balzac* did not give up for all that, and forty-one years later, Georges Lecomte, having become president of the Société des Gens de Lettres, inaugurated the bronze that had been placed at the intersection of Boulevard Raspail and Boulevard Montparnasse. Despiau and Maillol thus unveiled the object of so much scandal on July 2, 1939. Sculpture and all of the other arts had experienced such pro-found transformation since the end of the nineteenth century that the erection of the *Balzac*, both as hom-age and reparation, was the recognition of a landmark work that was indispensable for the understanding of this evolution.

# Rodin rediscovers
## the essence of sculpture

**Balzac Standing**
*1892-1895, terracotta,*
*0.255 x 0.111 x 0.112m.,*
*Meudon, Musée Rodin.*

A sketch in which the basic forms – fat belly,
spreadlegs – are visible despite the brisk and
rudimentary modelling which still shows
thumbprints; the *Balzac* comes slowly into being.

More than any other of Rodin's works, the *Balzac*
demonstrates his specific aesthetic choices.
Sculpture, for him, was foremost an art of modelling
which had to be freed from the slavish restitution of
likeness. The point was to use plastic effects to trans-
mit the truth, life and power of a figure. Expression was
mediated by the modelling. The *Balzac* is characterized
by an upward thrust, an upwelling of energy that swells
the surfaces from the inside. Rodin achieved monu-
mentality this time not just because the statue stands
three metres tall, but by the interplay of the volumes and
their extreme simplification. The fall of the drapery,
unencumbered by accessory details, helps to anchor
the figure. Rodin applied the lessons from his *Burghers*
to create the expressive exaggerations of the neck and
face; the hollows and prominences, which were accen-
tuated almost to the point of caricature, were meant
to bring out a play of light and shadow. It may rightly be
said that, in his *Burghers* and the *Balzac*, he drew on
the more primitive aspects of sculpture.

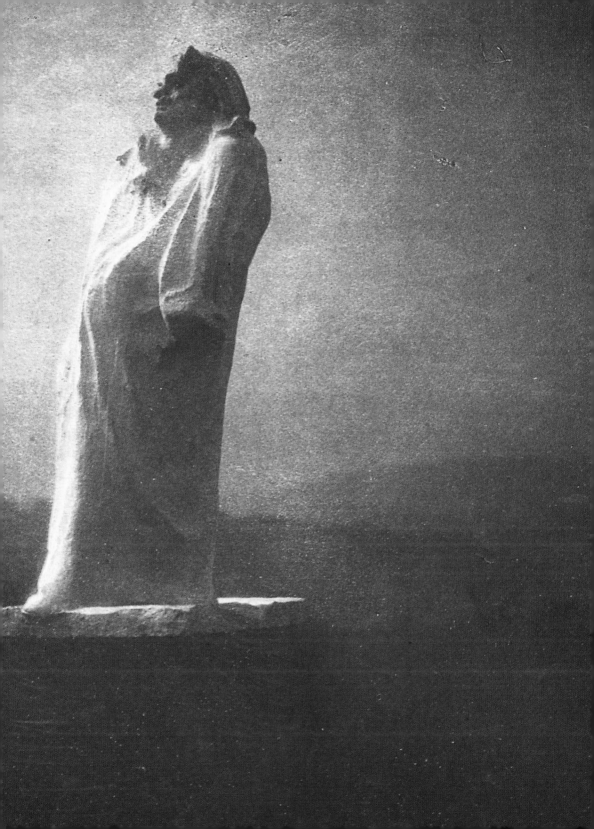

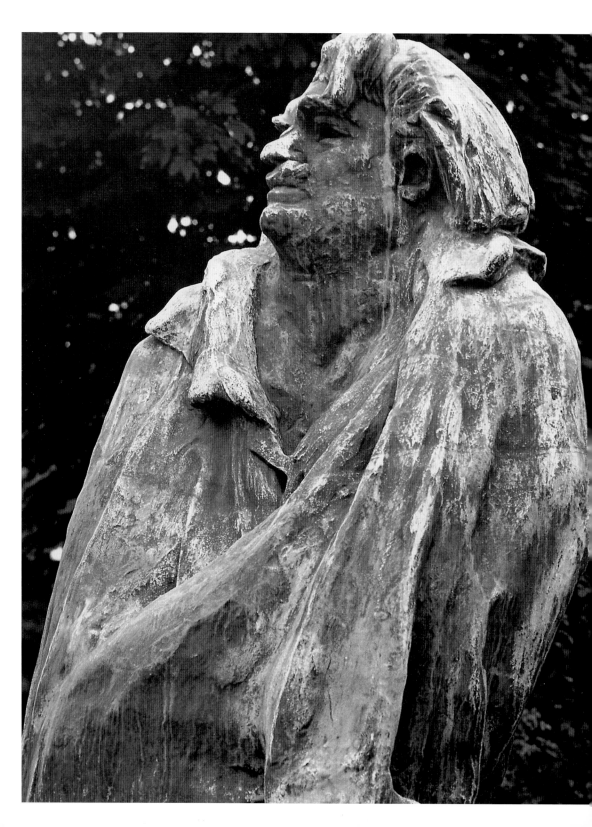

Previous page:
**Balzac, « Towards the light, midnight »**
*1908, photograph by Edward Steichen, Paris, Musée Rodin.*

After being rejected by the Société des Gens de Lettres
and the object of scandal at the Salon of 1898, Balzac's
statue stands in splendid solitude in the garden of the Villa
Brillant at Meudon.

**Monument to Balzac,** definitive state
*1895, bronze,*
*Paris, musée Rodin.*

These two works were exemplary accomplishments in the field of public sculpture, or "sculpture en plein air", as it was then called. In his long preface to Rodin's *Les Cathédrales de France*, published in 1914, Charles Morice wrote: "No one doubts any more that the *Balzac* is a major work of decorative or plein air sculpture, something new in modern art. It is at the same time a powerful achievement and a fertile guide which the future will have to take into account." After the *Burghers*, these "expressive and decorative outdoor figures", these "gothic figures", Rodin created his *Victor Hugo* and his *Balzac*, in which he "associated more closely than ever before the sculpture with the vibrancy of the atmosphere, accentuating certain planes and reducing others, gradually, giving priority to the modelling, but only to the most essential modelling". Rilke made the same observations, and, on the eve of the inauguration, Mirbeau pointed out in *Le Journal* that: "The sculpture of Mr. Auguste Rodin is especially precious because its contours are cleverly atmosphered, and as such it is doubly beautiful in the open air and light of a public space." This was no mean praise when one recalls that, in 1895, Rodin had so far inaugurated only the monuments of Bastien-Lepage and Claude Lorrain.

Rodin became very famous nonetheless, exhibiting in London in 1898, at the Vienna Secession, in Brussels in 1899, and in Amsterdam. He inaugurated his own pavilion at the 1900 Exposition Universelle, while publications on his work appeared in increasing numbers. With Bourdelle and Desbois, he founded the Académie Rodin, and his studio became a meeting-place for socialites and cosmopolites of every stripe. Grunfeld quoted this information in *Guide des Plaisirs de Paris*, under Rodin's address: "Extreme intensity of life. Searching for new paths in sculpture (receives Saturdays)." Yet, in this whirlwind of success, he gradually lost the will to struggle.

The great commissions hung in suspense. In 1904, after the fray over the *Balzac*, he was an easy target for

detractors who deplored the outlay of funds made to a sculptor who never delivered his goods: by then, he had received 24,000 francs for the *Gates of Hell*, 30,000 francs for the first version of *Victor Hugo* and 11,000 francs for the second, yet not a single one of these monuments had been completed. The inventory of his oeuvre could have been taken from his showing at the 1900 Exposition. Symbolically, apart from a bust, he was represented only by *The Kiss*. In his one-man pavillion at the Place de l'Alma, following the example of Courbet in 1855 and Manet in 1867, he presented 168 major works, including the *Gates*. He arranged to have his sculptures flooded with daylight from large windows. As he explained: "I believe indeed that sculpture is an outdoor art, and I find it unworthy of artists to create a work intended to be seen only from one specific viewpoint." He had reached the peak.

The new commissions that followed inspired no further inventiveness. Rodin merely exploited, recombined and reworked existing pieces. He had always done this of course, but his creative efforts shifted from monumental sculpture to figurines of dancing girls and fragments, or to drawings which he turned out by the thousands. Thus, although he had switched from one type of production to another, he continued to create and innovate, but in such a radically different mode that he disconcerted even more, and the exhibition of an unfinished *Hugo* or of fragmentary pieces seemed a further provocation. In fact, Rodin was just pursuing his pioneering efforts and further paving the way to modernity.

# Rodin's
## modernity

# Heritage

An approach which stresses Rodin's modernity should not obscure the extent to which his art contained references to and was the synthesis of most of the great epochs of sculpture. "I have studied the antiques, the sculpture of the Middle Ages, and I have returned to wholesome and reassuring nature... I am in the tradition of the primitives, the Egyptians, the Greeks, the Romans. I have endeavoured only to copy nature. I interpret it as I see it, according to my temperament and my sensitivity."

He claimed to have been a student of nature, yes, but he first meditated on the works of all of the previous masters, both the famous and the anonymous. It was precisely because of this knowledge that he was able to leave all the other stylistic schools behind and find the means of his own art, to develop a craft which connected him to the tradition of the Ancients, the Gothics and the Renaissance.

**Resting Satyr**
*Antique marble from Rodin's collection,*
*1.04 x 0.554 x 0.365 m.,*
*Paris, Musée Rodin.*

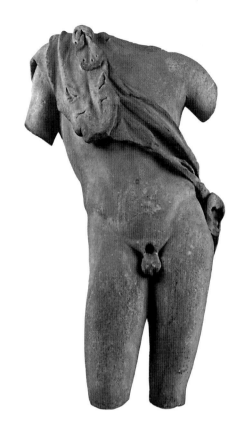

## From Phidias to Michelangelo

Somewhat given to pontification in his later years, Rodin wrote a *Testament* to young artists which begins with these words: "Bow before Phidias and Michelangelo." In his eyes, these were the two masters who represented two peaks in the history of sculpture and two opposite concepts of expressivity.

Rodin never stopped worshipping the Ancients, not only by collecting antiques, figures of Venus, vases, Tanagra dancers, but also by studying them closely in the original at the Louvre and at the British Museum, where the sculpture fragments removed from the Parthenon by Lord Elgin were preserved. According to him, there was an overestimation of the extent to which the Greeks idealized forms; they also followed nature closely and expressed life through modelling.

To illustrate the principles governing the composition of antique statues, as opposed to Michelangelo's manner, he sketched two statuettes in front of Paul Gsell. One of these "presented four alternately contrasting planes from the feet to the head" and "a gentle undulation" which gave an "impression of tranquil charm": this was of course the classical way. The other figure, he explained, "instead of four planes", has "only two, one for the upper part of the statue, and a contrary one for the lower part. This makes for a gesture that is both violent and contained." The bust in this example, being bent forward, "produces very strong shadows".

He concluded that: "In effect, the mightiest genius of the modern age celebrated the epic of the shadow, while the Ancients sang the praises of light." Knowing this, we can see why certain arched female torsos were in fact Hellenistic manifestoes, hymns to a luminous femininity, while his Adam , an expression of anguish, was condemned to languish in the shadows. It follows from this that what Rodin considered to be Michelangelo's art was the product of a meditation on the Gothics.

**Project for The Tower of Labour**

*1893-1985, plaster,*
*photographed by H. Lacheroy,*
*Paris, Musée Rodin.*

Model for the monument in Rodin's studio
showing the overall composition, with crypt,
colossal statues, central column with carved
reliefs. Rows of busts may be seen in the
background.

**Pediment of the St Peter's**
**Abbey in Auxerre**

*Around 1881, graphite, stump, pen and ink wash,*
*touched up with gouache on ruled buff paper,*
*0.091 x 0.144 m., Paris, Musée Rodin.*

Examples of the hundreds of sketches made
by Rodin when he visited cathedrals in search
of what he called the "French genius"
of the medieval craftsmen.

**Rodin and Mrs Simpson**
*1903, photographer unknown,
Paris, Musée Rodin.*

## The dream of the cathedral

Someone as attentive to contours and to contrasts of light and shadow as Rodin was, was necessarily also fascinated by cathedrals. In fact, he drew them insatiably, setting down the salient details and the contours of the mouldings, but no exact indications of perspective. As with his drawings of nudes, he highlighted them with washes or scored them with hatching. Like Monet in front of the Rouen Cathedral, what he was seeking was effects of light. To his way of seeing things, architecture was a form of monumental sculpture. Cathedrals were a constant point of reference, and not just in one particular composition of hands or in his rhetorical image comparing the unfinished state of his works with that of certain cathedrals, but because of the mastery of volumes demonstrated by the artisans who made them. Charles Morice told the story of his discovery:

"This scorned art was the great Art. All the secrets of outdoor sculpture were known to the Gothics. Experimentation with drapery and modelling, the sacrifice of details to the overall scheme, the dual adaptation of the decorative figure to the monument it adorned and to the atmosphere in which they were bathed together, all of this had been felt, thought out, and realized by these humble artisans so disdained by the professors." Not surprisingly, therefore, he eventually designed a monument which may not have been gothic by its forms, but certainly was so in feeling. His *Tower of Labour*, the product of an era nostalgic for the great causes that had galvanized the Middle Ages, was intended to promote values that were more social than religious in nature. In 1898, he designed a sort of Italian bell-tower wrapped around a Trajan Columnlike affair decorated with reliefs of the progress of humanty, in particular the epic of Work and the transition from the material to the spiritual realms. Its crowning glory, a group of angels called the "Bénédictions", showered love and joy on the workers below. Assuming the role of a medieval architect, Rodin saw himself directing legions of sculptors, and finally being buried in the crypt beneath the tower. The project, however, did not generate the enthusiasm that he had expected, and the model

itself was sometimes mocked as being another of his – this time, truly – impossible projects.

Eugène Carrière sensed Rodin's nostalgia for a great collective work like those made by the medieval craftsmen. In his preface to the catalogue of the 1900 Exposition, he wrote: "Rodin's spirit of generalization has condemned him to solitude. He was never able to collaborate on the unmade cathedral." This dream of the cathedral was one of the avenues that Rodin explored to break loose from the conventions of his day, and it was a dream that he shared with not a few contemporaries, including Constantin Meunier from Belgium and Jules Dalou: to put the traditional forms of the cathedral builders and medieval corporations at the service of modern, secular values like Progress and social idealism. Yet Rodin owed more than just this aborted project and some emphatic and fuzzy pronouncements to his contemplation of the cathedrals; through it he found a confirmation of his new approach: "Modelling, depending on the plane, is the life of architecture and sculpture, the soul of the stones touched by the artist."

## The art of modelling

The primacy of modelling over the subject was a crucial factor. In 1900, an art critic by the name of Yvanhoé Rambosson had already understood the revolution effected by the great sculptor at a time when Symbolism still held sway. Stressing the sense of light and modelling in Rodin's work, he distilled the following principle: "Ideas are not what generates form: forms generate ideas. Only one thing counts in sculpture, to express life, and it is expressed only through modelling."

Modelling was revealed to Rodin one day by one of his assistants, a certain Constant, who explained that forms should be considered not in terms of extension, but in terms of depth. This was the key to sculpture. He still had this lesson in mind in 1909 when he told Paul Gsell: "Instead of imagining the different parts of the body as more or less flat surfaces, I saw them as the projection of inner volumes. In each swelling of a torso or limb, I strove to give a sense of the muscle or bone that ran beneath the skin." This, according to him, was how the Ancients had worked too. He demonstrated this to

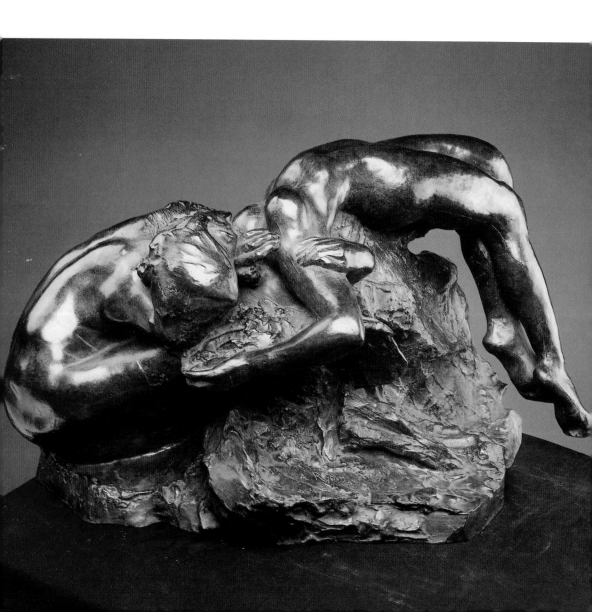

Gsell by moving a lamp around a Venus. Was it not also this factor which made him one of the first artists to be receptive to the so-called primitive arts? Jules Renard reports how, at the 1900 Exposition Universelle, in the pavilion of the Dutch Indies, Rodin had stood "in great admiration" in front of one of these "small childish sculptures". Indeed, who else at this time could have seen anything other than puerile efforts in this "savage" art? In this respect, too, Rodin was in the vanguard; yet he was only following his own logic.

Louis Gillet, an art historian he sometimes consulted, summarized this experience thirty years later at the 1937 Exposition Universelle, which featured a retrospective of sculpture from the twelfth century until 1900 – in other words, until Rodin: "We have discovered the value of archaic art... There is an eternal lesson in the art of the beginnings." Then he expounded on Rodin's principles: "The language of the sculptor resides entirely in modelling, that is, in the art of using depth, of varying and composing the masses of

shadow and the masses of light... Each sculpted object has to be able to create its own atmosphere. A true sculpture generates its own aura, its own breathing space." We are back with the idea of plein air, or open air. Gillet then quotes Rodin: "Life does not come from without, like a cast: a body is not formed on a lathe, like a baluster, nor is it moulded like a candle. A sculpture must be made from the inside."

**Fallen Angel**
*1895, bronze, 0.38 x 0.698 x 0.409 m.,*
*Paris, Musée Rodin.*

Demonstrating Rodin's Baudelairian inspiration, this group was formed from two females figures from the lintel of the *Gates*: the *Torso of Adèle* and the *Caryatid*.

Rodin's work is the fulfilment of an ideal that the art theorist John Ruskin had already formulated in 1849: "Sculpture does not consist in carving a form in stone, but of carving an effect... The sculptor must paint with his chisel. Most of his blows are not supposed to realize the form, but to communicate strength to it; they are blows of light and shade; they produce an edge or carve a hollow, not in order to make a real edge or a real hollow, but to obtain a line of light and a patch of shadow." As it was, Ruskin had already mentioned "old French wood sculptures". This return to the source was Rodin's strength: whether we consider classical, Romanesque or Gothic sculpture, whether Michelangelo or the sculptors of the eighteenth century, he had assimilated their lessons.

Modelling, movement and expression, Rodin's fundamental trinity, could not exist without air or light. At a time when the death of sculpture was being proclaimed, he was rediscovering its basic principles. And simple though they were, they were enough to ensure its revival. The masters of the past provided a justification, but Rodin was not content just to effect a synthesis; he developed their legacy through his own special and fertile experience. Nor did he peruse the lessons of the past in order to establish a new academicism, but rather to liberate his art from it. In this way, he could participate in all the artistic movements of his time without being bound to any one in particular.

There is no doubt that he benefited from the freedom achieved by the generation of the Romantics, and he never departed from a certain penchant for pathos. We have already seen his affinity with Préault, for example. Furthermore, Rodin might appear to belong to the various movements derived from Romanticism, like Realism, Symbolism or Expressionism. His careful attention to life and his concern for truth make him a Realist, if not a Naturalist; consider his *Age of Bronze*, which was so lifelike that he was accused of having made casts from life. Then, there are certain works with subjects inspired by Baudelaire, or close to the Symbolist tendency — exaltation of the woman (as Femme Fatale), the headless *Saint John the Baptist*, or couples like *The Eternal Idol* or *Fugit Amor*, which could be interpreted as images of human destiny — not to

mention titles that alluded to the spiritual preoccupa-
tions of the Symbolists. Others have seen certain of
his marble sculptures as being related to the Art
Nouveau aesthetic. A nascent Expressionism has been
noted in the excesses of his reliefs, the dramatic inten-
sity and gestures of certain figures, like in the
*Burghers* or the *Balzac*, and in his fondness for primi-
tivism, whether of archaic or of exotic origin.

Yet all of these readings and classifications, even
if partially true, overlook the primordial dimension of
Rodin's work: his breaking away from literary sculpture
and the primacy he gave to formal means. He sought
first and foremost to transcend all conventions,
whether grounded in history, as in Neoclassicism, or
in nature, as in Realism. In these movements, artists
generally looked outside their medium for their prin-
ciples. True creators, however, like Rodin, found them
within themselves and in the qualities specific to their
art-form. This is maybe what makes Rodin appear as
a kind of demiurge.

# Aesthetics
## of the fragment

If Rodin had been prone to theorizing, he could have paraphrased Maurice Denis, a young painter and theoretician thirty years his junior:

"Remember that sculpture, before being a war horse, a female nude, or an anecdote, is essentially a volume in which the play of light and shade has been arranged in a certain order." Rodin's achievement, apart from the expression of his vision of man and woman, was the liberation of sculpture and a redefinition of its specific identity as a medium, parallel to what had happened in the field of painting. Whether in his monumental, often public, statuary, or in the smaller-scale works destined for collectors and the art market, he established the principles that were to govern modern sculpture: the refusal to subordinate formal values to anecdotal subject-matter, the expressive quality of the fragment or of the work in progress, the primacy of modelling over resemblance, and the exaltation of the creative gesture.

### Arbitrariness of the title

A title is a sign, a conventional identification, an instrument of the work's individualization: anonymous figurines from the tangled masses of the *Gates of Hell* were given titles when they were taken out of this con-

text and sold as independent creations. This baptism was a crucial act, for it gave the statue a meaning, even if it could lead one astray.

It has often been said that Rodin left the choice of titles up to his visitors, or that the titles could change from one visit to the next. Jules Renard, writing in his daybook in 1891, recorded this scene: "Rodin, a sort of preacher, the sculptor of the pains of pleasure, naively questioned Daudet and asked him what his amazing creations should be called. He comes up with commonplace names, from mythology for example." References to mythology and classical history were an academic convention to which Rodin often paid lip-service, not shrinking from choosing very obscure episodes, like *Hecuba Barking*, or *Zephyr and the Earth* (which later became *Eternal Springtime*). This was a good way to palm off a subject that was either too erotic or too revolutionary in form. This practice proved to be detrimental to the sculptor's intentions, for the literary content from which he had freed his work – a step in the direction of modernity – returned with a vengeance via the name game.

If titles were of little concern to Rodin, it was because, except in the case of specific commissions, he had detached himself from the subject. Thanks to the *Gates of Hell*, naturally, he could begin to indulge in the free creation of forms, of bodies without stories, and titles could always be found when individual pieces were used elsewhere. *The Metamorphoses* of Ovid, a pair of lovers from 1885, deserved its other title – *Desire* – more, but it was also called *The Twins*, *Castor and Pollux*, *Les Fleurs du mal*, after Baudelaire, and *Death and the Maiden*, after Schubert.

Must one delve deeper into the allusion to Baudelaire in a case like that of *I am Beautiful* (*Je suis belle*)? This particular group was also called *Carnal Love* (more suggestive), *The Rape* (more realistic), and *I Hate Movement, Which Displaces Lines* (from a sonnet by Baudelaire), and *Beauty* (the "definitive" title). Gustave Kahn called this "the consultation on the title":

"Rodin allows us to admire. 'What should we call that?' This was the consultation on the title, to which all of his friends were subjected. This had come to him from a movement of the model! It came out with an admirable rhythm. But what is it? What it is, he knows, but he searches for the order of ideas with which it should be associated. A male nude; does that not require a mythological denomination? He is inclined to think so, but to which demi-god or hero should this imploring old man be related, for example? The visitor suggests this title. A small pencil ambushed in Rodin's hand suddenly appears. A word in tiny letters will be inscribed somewhere on the base, or on the plaster, if the sketch has been cast, next to another title, in a succession of graffiti that might be amusing in their diversity, but this diversity does not make Rodin smile, for, in his opinion, his formal invention contains enough general beauty to admit all hypotheses."

**Seated Female Torso**
*Plaster, 0.485 x 0.219 x 0.199 m.,*
*Meudon, Musée Rodin.*

The mutilation of this torso in the manner of an antique helps bring out the perfect modelling of the back and hips.

**I Am Beautiful**
*1882, bronze, 0.69 x 0.308 x 0.319m.,*
*Paris, Musée Rodin.*

Group formed by the figures of the Falling
Man and the Crouching Woman derived from
the Gates (upper part of the right pilaster)
and given a title taken from Baudelaire's
sonnet Beauty.

Aside from the coyness implicit in this name game which he left to the discretion of his visitor or some winsome female, and apart from the ease with which he re-used his works, these anecdotes are very revealing. With the exception of his commemorative works, Rodin created without overly bothering himself about the subject-matter. He looked for a form or noted a transient gesture made by the model and gave it a title out of pure convention. Another modern feature is the many levels of interpretation in the work, the spectators being free to read it in their own particular way.

These details throw a more relative light on the import of the titles, and so on the Symbolist tendency that some have detected in works which, in fact, owe their title to someone other than the sculptor. This same arbitrariness became downright blatant when, in 1909, out of a female nude mutilated "à l'antique", he created a work called *Prayer*. If this was not meant in an ironic sense, then we can only infer a sacralization of the female body in the sense already discussed.

In anticipation of certain contemporary practices, Rodin would very well have been content just to number his works, like a musician his symphonies.

## The bust, a conventional fragment

We tend to forget because it has become such an entrenched tradition, but a bust is a fragment. To be sure, it is the most expressive fragment, and the importance of the head and face has justified such partial portraits since Classical times. Rodin sculpted more than a hundred portrait busts. Among his first efforts were portraits of his father and of Father Eymard. Executing busts was part of his livelihood, especially during his Belgian sojourn. He was also in the habit of honouring friends and benefactors by sculpting their busts; dozens were given away in this manner. Althought his swiftness of execution became legendary, he still needed lengthy sittings, and not all of his models could grant him enough time; hence a number of unfinished busts, like that of Pope Benedict XV.

Rodin owed some of his fame to these busts; they were in any case much less controversial and often exhibited at the Salon. The busts of Victor Hugo and Jules Dalou from 1884, and that of Antonin Proust from 1885 were all presented at the Salon of 1889. The portrait of Mme Morla Vicuna, exhibited in 1884, was purchased by the State. So widely did his reputation

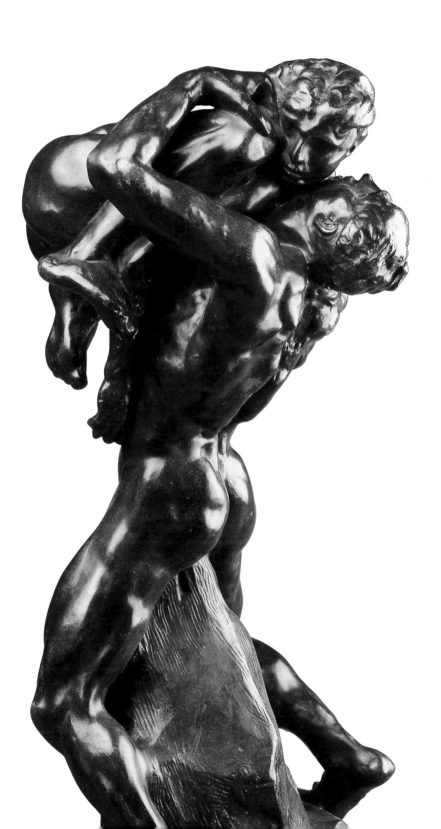

**Jean-Baptiste Rodin, the Artist's Father**
*Around 1864, bronze, 0.415 x 0.28 x 0.24 m.,*
*Paris, Musée Rodin.*

Although his father had a beard, Rodin
portrayed him in the classical manner as a sort
of Roman senator.

spread that he received orders from all over the world, especially from Great Britain and the United States. His clientèle was composed of wealthy collectors or socialites who called on his services even if, under the influence of the Duchess of Choiseul, his prices soared to 40,000 francs for a portrait. His procedure was to make a clay model and to have one of his assistants – very often Jean Escoula – carve the definitive marble version. In fact, some of his most noteworthy portraits were in bronze, like the bust of his friend the engraver Alphonse Legros (1881) or that of George Wyndham (1903), the British Secretary of State, who voiced the universal significance of his portrait by calling it an image of "the forty-year-old man".

One of his most charming marble portraits – apart from the head of Camille just barely emerging from the block, which became a symbol of thought (*La Pensée*) – was that of Eva Fairfax, a young Englishwoman who had captivated him. The vague contours and fin-de-siècle undulations which he gave to the forms rendered the delicacy and grace of the sister. Although the bust was a conventional genre, Rodin nonetheless used it for daring formal experiments, with the result, however, that sometimes his sitters could not recognize themselves: this was the case with Jean-Baptiste Rodin, Father Eymard, Henri de Rochefort, Anna de Noailles, and Clemenceau, among others. The reason was that Rodin was more concerned with the quality of the madelling, the expression of character, and artistic truth, than with the mere rendition of external appearances. His portrait of Clemenceau (1911), of which over twenty sketches have been preserved, displays very conspicuous modelling to bring out the characteristic features of the statesman who was known as the "Tiger". The bust of the Japanese actress Hanako provided him with the opportunity for an equally rich exploration: a series of plaster and terracotta sketches demonstrates the range of expressions and theatrical mimicry that he was able to capture. These busts are among Rodin's most expressionistic works. They also indicate his interest in the Far East, which was sparked by the visiting Cambodian dance troupe. He was so fascinated by Hanako's face that the often

reworked it; one day, he gave it a mane of hair and told Léonce Bénédite: "'It's Beethoven... I am going to do a Beethoven...". Thus, like the figures of the *Gates*, even a portrait-bust could become the starting point for a new work; and so Mahler could be transformed into a *Mozart* (1910) and *Mrs. Russel* (1888) into a Pallas.

Working directly from life was an essential condition for Rodin: for his *Burghers*, he looked all over for friends who corresponded to his idea of the individual figures, and even went so far as to pick them according to their native region (he was a great believer in regional types). His friend, the painter Jean-Charles Cazin, born in the Pas-de-Calais, posed for the figure of Eustache de Saint-Pierre. The *Balzac*, as we have seen, also occasioned a similar search.

Characteristically for Rodin, however, a fragment or a mutilated figure was just as worthy of his attention and could become a masterpiece in its own right. Indeed, the play of light is just as intense on an arm or a torso, as on an entire figure.

Following pages:
**Thought**
*1886, marble, 0.742 x 0.435 x 0.461 m.,*
*Paris, Musée Rodin.*

Camille Claudel was the model for this symbolic work in which the pure and finefeatured face of thought emerges from a rough block of marble.

**Portrait of Georges Clemenceau**
*1911, bronze, 0.5 x 0.32 x 0.25 m.,*
*Paris, Musée Rodin.*

Unrealistic in its handling, this bust renders the combative character and strength of the sitter, who thought it made him look too "Japanese".

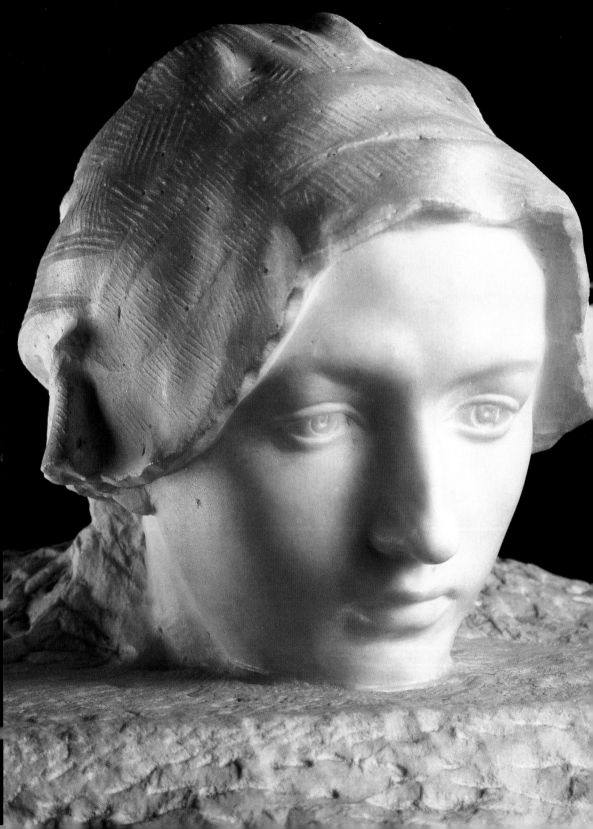

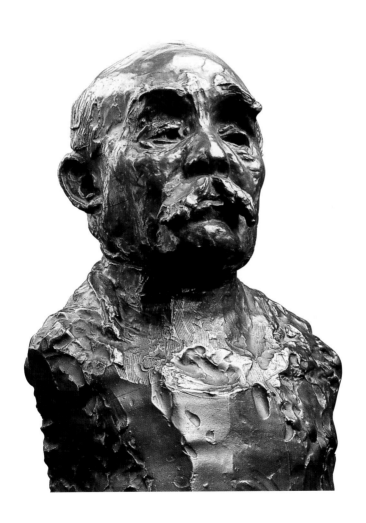

**Mme Mona Vicuna**
*1884–88, marble,*
*0.56 x 0.499 x 0.37 m.,*
*Paris, Musée Rodin.*

This portrait-bust was purchased from the sitter
by the State as soon as it was created; the marble
was shown at the Salon of 1888.

## The body in pieces

The example of classical marble sculptures, many of which have come down to us in pieces, was surely involved in Rodin's fascination with mutilated figures: after all, a fragment was enough to reconstruct the genius of a Phidias. Throughout his career, Rodin meditated on antique sculpture; his collection included a number of mutilated female figures and even a replica of the *Satyr* by Praxiteles. He based himself on the *Apollo Belvedere* for a decorative composition in the Palais des Académies in Brussels (1884), and again for his *Ugolino* and *The Thinker*. He wrote about the *Venus of Milo*. *The Torso of Adèle* (1882) appeared repeatedly in his compositions, and he finally used simple torsos, without head or arms, exhibiting them with no other title than *Male Torso* or *Female Torso* (both at the Salon of 1910), or *Flying Figure*. In other cases he gave a more elaborate title to a fragment, like his *Psyche*, or *Prayer*, from 1909, which was the torso of a young woman that recalled a simplified copy of the *Maenad* attributed to the Greek sculptor Skopas. Rodin accumulated hun-dreds of these body fragments, which he called his "abattis" (limbs from a slaughtered animal), and kept his assistants busy turning them out.

When asked why he did not give his statue a head, Rodin replied: "The head? Why, it is everywhere!" The expressivity of a back, a torso or a hand can be every bit as eloquent as that of a face. In his 1911 study of Rodin, the German philosopher Georg Simmel noted that:

"Rodin has conferred the character of a face to the entire body; the faces of his figures are often less accentuated and less individualized, and all the spiritual motion, all the radiant energy of the soul and its passions, which were normally externalized in the face, are manifested in the way the body unfolds or turns inward, in the tremors and thrills that course along the surface, in the commotions which, starting at the centre of the soul, are translated by the curling and springing of these bodies, by their earthbound compression or by their aspiration to flight."

The same observations could be made about the hands. The 1990 exhibition at the Musée d'Orsay titled *Le Corps en morceaux* (*The Body in Pieces*), which

was almost entirely devoted to an analysis of Rodin's working methods, demonstrated how each part of the body could generate works in which formal qualities took precedence over meaning. And yet, a fragment can still be charged with meaningful or symbolic values, whether by way of allusion or intrinsic meaning. Rodin sculpted hundreds of hands, not only for complete figures, but also because of his irrepressible fondness for the expressive detail. These hands would eventually find their way into compositions: the *Large Clenched Hand* combined with an imploring figure, and the famous pair of right hands, disposed in an ogival shape or evocation of prayer, were titled *The Arch of the Covenant* and *The Cathedral* (1908). This last motif was taken up again in a small marble called *The Secret*, in which two right hands close on each other. The religious connotations of these works were obvious: the hand refers to creation because Rodin was a sculptor who worked more often by directly modelling the clay than by carving. "His *Hand of God* is his own hand", remarked George Bernard Shaw, who sat for him in 1906.

Following pages:
**Hanako**
*1907–1908, bronze,*
*0.18 x 0.113 x 0.125 m.,*
*Paris, Musée Rodin.*

Thanks to the richness and novelty of her theatrical expressions, Rodin executed no less than fifty-three portraits of this Japanese dancer.

**The Farewell**
*1892, plaster,*
*0.39 x 0.45 x 0.306 m.,*
*Paris, Musée Rodin.*

Typical example of the assemblage technique used by Rodin; here, a youthful head of Camille Claudel was combined with hands that seem to have been derived from sketches for the *Burghers of Calais*. Camille at this time had quit the studio she shared with Rodin.

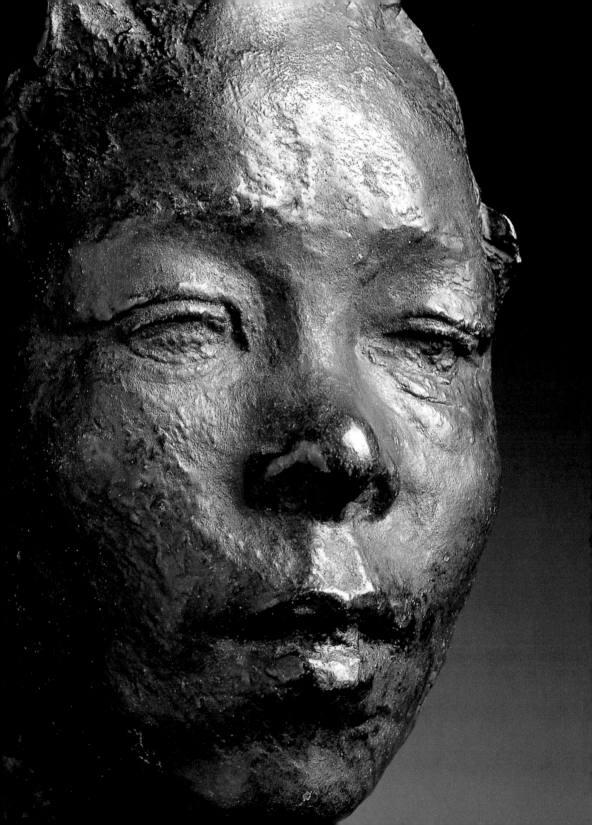

## Incompleteness

The fragment is by nature a study, a preparatory sketch. With Rodin, however, the fragment became a work in its own right. In his quintessential modernity, he realized that the work no longer needed to be completely finished.

"Nothing but fragments, one after the other, [Rilke wrote] nudes the size of my hand, others larger, but only in pieces... And yet the more one looks, the more one senses that all of this would be less whole if each figure were so. Each of these debris possesses such an exceptional and striking coherence, each is so indubitable and demands so little to be completed that one forgets that these are only parts, and often parts of different bodies, which here are so passionately alike. One suddenly realizes that conceiving the body as a whole is more the work of a scientist, and that the work of the artist is to create new relationships with these elements, new unities which are greater, more legitimate, and more eternal." This was indeed the nature of Rodin's discovery.

To be sure, Michelangelo had also used non-finito, but with Rodin the fragmentation and incompleteness went much further and became established as principles. It was not just a matter of the co-existence of polished and rough marble, one of the hallmarks of the Florentine, whose *Slaves* became far-reaching symbols of a spiritual, or merely human, nature. Rodin was known to mutilate a piece deliberately, breaking

**Rodin in his studio**
*Photographer unknown,*
*Paris, Musée Rodin.*

The sculptor in the midst of works and fragments from the pavilion that he rebuilt in Meudon.

it up and keeping only a fragment, or asking his assistants to stop working on it. When he exhibited them, or unfinished works like the *Victor Hugo* at the Salon of 1897, this was taken as a provocation. It was easy to take him to task for not being able to finish a piece or to produce a complete work. This was because of the novelty of his working methods: he used several intermediary casts and worked on them in parallel, achieving different results or states which he either carefully preserved or abandoned. In some cases he would work simultaneously on almost a dozen casts of the same bust. These casts could also be transferred from one group to another. Eventually, he came to the point where the work in progress seemed more important than the finished piece.

Gustave Kahn sensed that this endless series of casts, which were so many experiments, would achieve the status of works in themselves:

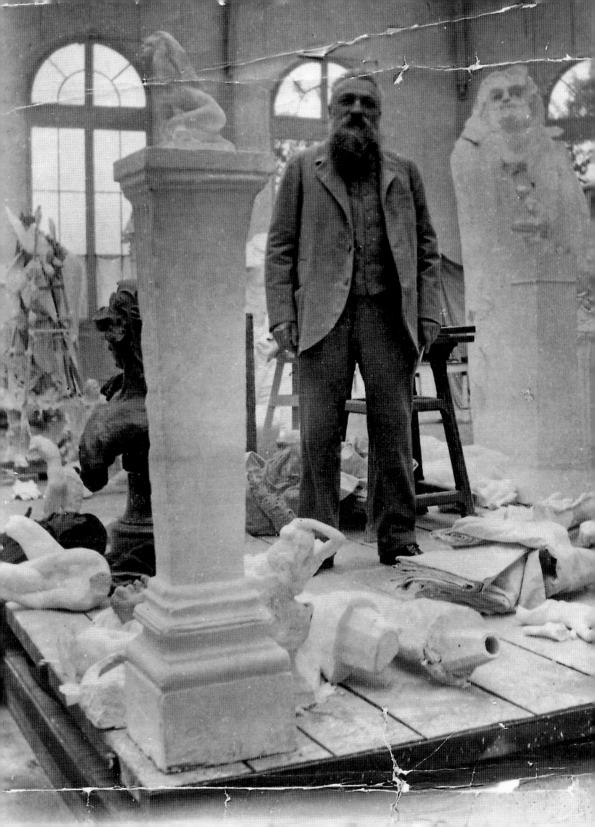

Previous page:
**Bacchanalia**
*Plaster, 0.412 x 0.48 x 0.435 m.,*
*Meudon, Musée Rodin.*

This strange composition was formed from two fragmentary
figures: the *Centauress* and a figure related to *Meditation*;
the forms and contours of this bold embrace are quite
harmoniously combined.

**The Cathedral**
*1908, stone, 0.64 x 0.34 x 0.32 m.,*
*Paris, Musée Rodin.*

This ogival shape is formed by two right hands; the title gives
this work a quasi mystical dimension.

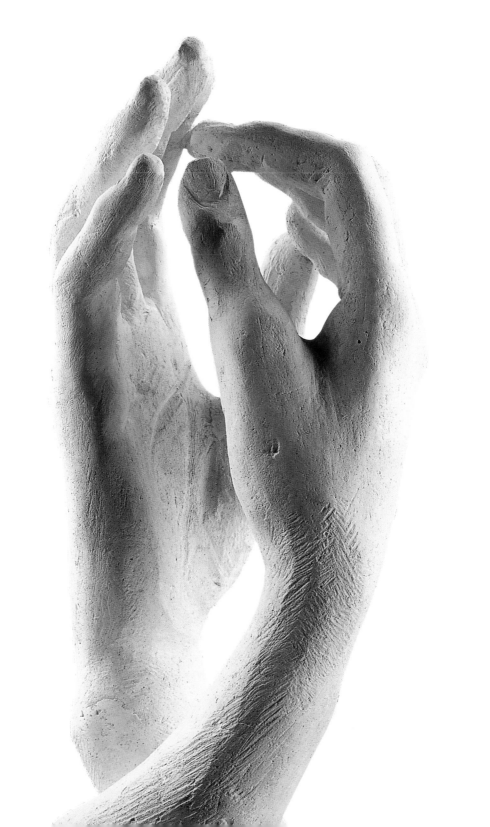

"They are approximations that will lead to the definitive solution. When glory comes, all of these sketches will be presented as states every bit as interesting as the final work. The casting stage, which was only a trial, becomes a station. From the time of his *Gates of Hell* onward, Rodin began to qualify his studies and fragments as works. Thanks to the verve and energy (if not perfection) which he brings to these preparations, these studies of outstretched arms or tensed hands will constitute, in his eyes, a whole which he will sell to admirers.... He is more attached to unfinished, but effective, studies than to certain of his small, completely finished works."

These were the pieces that earned him the most violent critiques, but also the enthusiasm of younger sculptors, like his disciple Bourdelle. At the Salon of 1910, next to fragments by Rodin, stood a *Hercules with a Bow* and a deliberately unfinished bust of a little girl by Despiau: in this juxtaposition, Guillaume Apollinaire saw the spread of "Rodin's fragmentary art".

In fact, the independence of a fragment considered as a work in its own right is a function of the artist's priorities. The quality of the modelling, and so of the expression, does not depend on the fact of its being finished.

"In the course of time", Gustave Kahn explained, "especially during his second manner, when he experimented with light on the model, he worked more and more towards partial studies. Not that he did not want to take the time to execute a finished figure. He did not consider this to be necessary. The fragment is beautiful in itself, and the study of the fragment, a useful and legitimate thing."

In short, he concluded, "it is more sculptor-like".

Following pages:
**Male models posed fighting**
*Photographer unknown,*
*Paris, Musée Rodin.*

Although he revolutionized composition in sculpture by using fragments and assemblages, Rodin nonetheless continued to work from life and almost exclusively after the human figure.

**Female model in Falguière's studio**
*Photographer unknown,*
*Paris, Musée Rodin.*

**Rodin's studio**
*Photographer unknown,*
*Paris, Musée Rodin.*

1  2  3  4  5  6  7  8

# The Hand
## of God
### or the artist's hand

**The Hand of God**
*1897, marble,*
*0.94 x 0.825 x 0.549 m.,*
*Paris, Musée Rodin.*

The original man and woman created out
of the primeval mud by the Creator –
in the image of the artist.

# Sacralisation

To George Wyndham, an English dandy who had
come to sit for his portrait, Rodin explained his sculp-
ture *The Hand of God*: "All of it is beautiful. The
modelling is all one. God made it to reflect light and to
hold shadow... It is the hand of God. It emerges out of
a rock, out of chaos, clouds. It certainly has the thumb
of a sculptor. It holds the mud and with it creates Adam
and Eve." The hand kneading the first man and woman
is the sculptor's own hand. It is the exact same hand
as that of God in *The Creation of Adam* on the Sistine
Chapel ceiling. With Rodin, an almost trite parallel
between the gesture of the sculptor and that of God,
between modelling clay and the original mud, takes
on meaning again. For not only did he sculpt figures of
Adam and Eve, but he endowed his creations with such
power that his own hand became a fitting symbol for
the very essence of art. This image should not be inter-
preted in the sense of the artist imitating the divine,

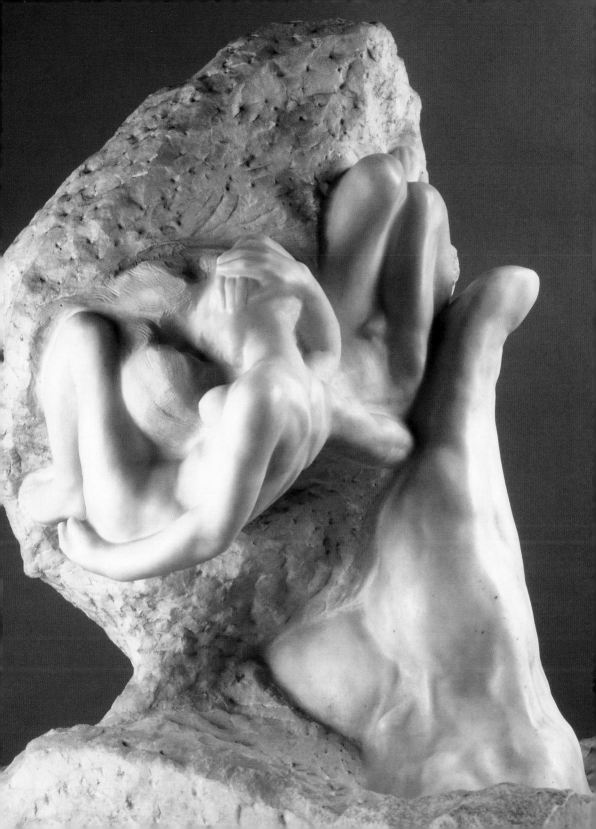

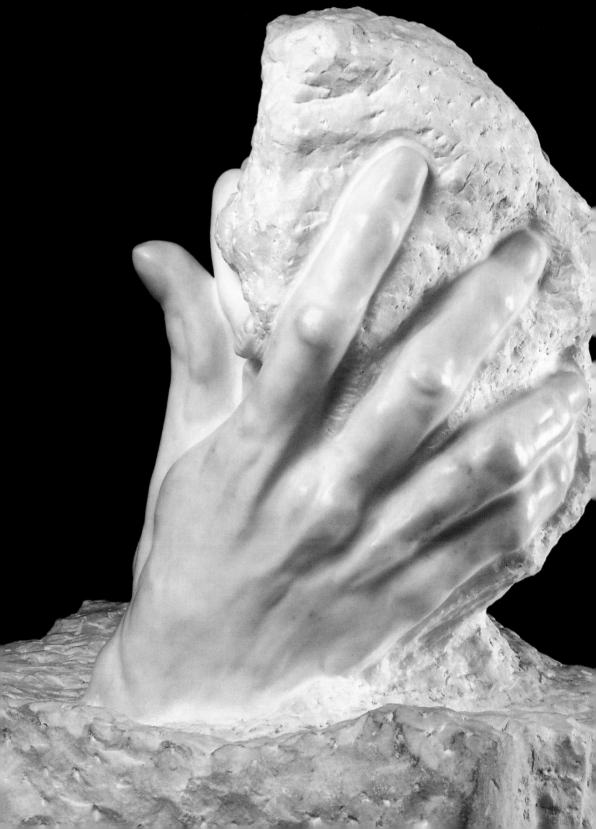

but of the artist creating his own world, and, beyond that, achieving mastery over matter. Even on his deathbed, in 1917, this parallel was asserted when a mould of his hand holding a small female torso was made. But, in comparison to the marble *Hand of God*, how feeble it seems, this cast of the hand that had created enough masterpieces to fill the careers of several sculptors.

To be sure, in this context and as soon as the hand is singled out, as in *The Cathedral*, art takes on a sacred tinge, and almost becomes a new religion. And, as he told Paul Gsell: "The true artists are, in essence, the most religious of mortals." In this respect, Rodin appears as a child of his times, searching for substitutes for the Christian faith. Yet, all the while elaborating a sort of mystique of art, he concluded: "The first commandment of this religion, for those who want to practise it, is to know how to properly model an arm, a torso, or a thigh!"

His irony aside, Rodin contributed to his own sanctification and that of his art by accepting the cult that developed around him as an exceptional artist, and by donating his work, thus giving the impulse to the foundation of his museum. Within his own lifetime he saw a shrine erected to his glory; the Musée Rodin was officially opened in 1916 in the Hôtel de Biron which had been his studio since 1908. This event, taking place in the midst of war, was to be the last scandal that he occasioned. Nevertheless, the group of Faithful that had defended him throughout his struggle, from *The Age of Bronze* down to the *Balzac*, succeeded in protecting this incomparable body of work from all the intrigues around his succession, and promoted it to the rank of a national cultural monument.

Rilke tells how the Master one day engaged in a sort of spiritual exercise, replacing the word "God" with "Sculpture" in the Third Book of *The Imitation of Jesus Christ*. The absoluteness of his love for this art, which gave him the strength to free himself from every convention extraneous to its essence, is here fully revealed: "I shall hearken to what Sculpture says within me (Ps 84, 8).

Blessèd is the soul who hears the voice of Sculpture speak from within…"

**Rodin's Hand Holding a Female Torso**

*1917, cast made by Amédée Bertault,*
*photographer unknown,*
*Paris, Musée Rodin.*

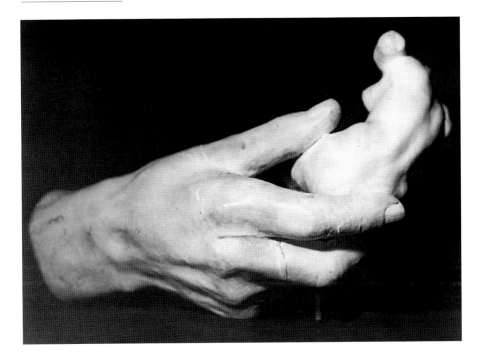

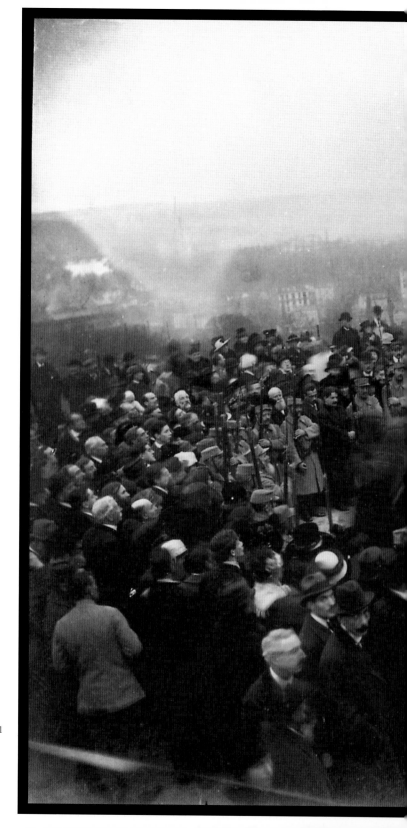

**Rodin's Funeral**
*November 1917,*
*photograph by Choumoff,*
*Paris, Musée Rodin.*

The artist was buried in Meudon
next to Rose Beuret, and with a model
of *The Thinker* as tombstone.

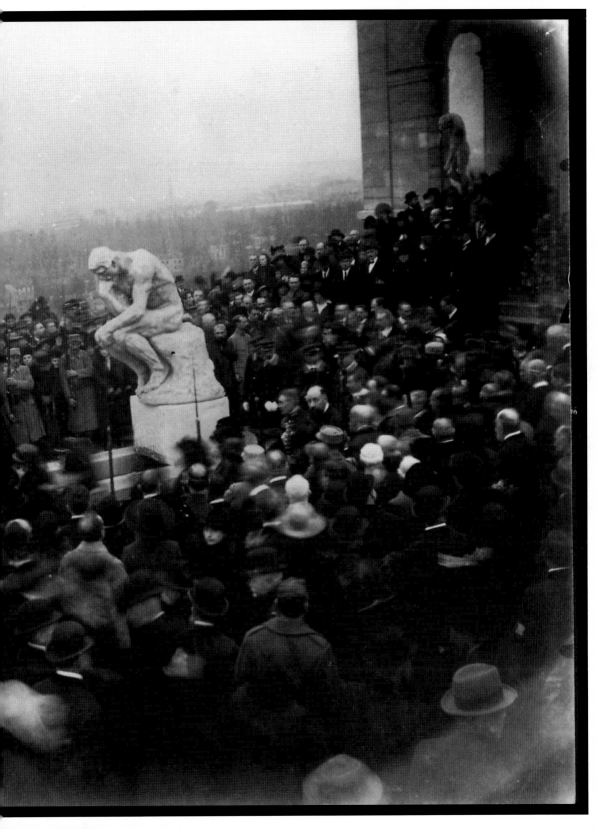

## CHRONOLOGY

**1840**  12 November, Birth of François-Auguste-René Rodin at
3, rue de l'Arbalète, in Paris.

**1844**  Birth of Rose Beuret.

**1851**  Studies at his uncle's boarding school in Beauvais.

**1854**  Enters the Petite École.

**1857**  Rodin finishes the Petite École and begins working for decorating
firms. Rejected by the École des Beaux-Arts in 1857, 1858 and 1859.

**1862**  Death of his sister Marie. Novice in the Order of the Fathers
of the Holy Sacrament.

**1864**  Birth of Camille Claudel. Meets Rose. Works for Carrier-Belleuse.
Attends Barye's class at the Museum of Natural History. Rejection
of the *Man with the Broken Nose*.

**1866**  Birth of Auguste Beuret. Stays in Strasbourg.

**1871**  Leaves for Belgium and works for Carrier-Belleuse at the Brussels
Stock Exchange.

**1873**  Partnership with Van Rasbourg, Carrier- Belleuse's successor
for the projects in Brussels (private buildings and the Palais
des Académies).

**1875**  Executes busts and other works for the Compagnie des Bronzes
(Suzon). Travels to Italy.

**1876**  *The Idyll of Ixelles*.

**1877**  Exhibits *The Vanquished* (*The Age of Bronze*) in Brussels, then in
Paris, after re-establishing himself there.

**1878**  Works on the Trocadéro, in Nice and in Marseilles.

**1879**  Works for the Manufacture de Sèvres. Contest for the monument
to the Defence of Paris.

**1880**  Exhibits *The Age of Bronze* (purchased by the State) and *Saint John
the Baptist Preaching* at the Salon, where he receives an honourable
mention. Commission for *The Gates of Hell* for the Musée des Arts
Décoratifs and assignment of a studio at the Marble Depository in
the rue de l'Université. Frequents the salon of Mrs Adam, where he
meets Gambetta.

**1881**  Travels to England, where he joins up with the painter Alphonse
Legros and executes his bust. Contest for a monument to Lazare Carnot.

**1882**  Portrait-busts of Carrier- Belleuse, Henry Becque, Jules Dalou,
Jean-Paul Laurens. *Ugolino*, *Je suis belle*.

**1883**  Bust of Victor Hugo. Meets Camille Claudel (?). Death of his father.
**1884**  Commission for *The Burghers of Calais*. Bust of Mme Mona Vicuna. Contest for the monument to General Margueritte.
**1885**  Exhibits the portrait of Antonin Proust. Commission for the monument to Bastien-Lepage. *The Martyr*, *Danaid*.
**1886**  Does not exhibit at the Salon, but at the gallery of Georges Petit (ten sculptures). *The Kiss*, *Thought*, head of Camille.
**1887**  Exhibits three of the *Burghers* at Georges Petits. Appointed Knight of the Légion d'Honneur. Decapitated Head of St John the Baptist, *The Sirens*, *Paolo and Francesca*, bust of Mrs Russel.
**1888**  Illustrates the *Fleurs du mal* for Paul Gallimard. Shares studio at the Folie Neubourg, Boulevard d'Italie, with Camille. State commission for *The Kiss*.
**1889**  First individual exhibition, with Claude Monet, at the Georges Petit Gallery. Exhibits several works at the Exposition Universelle. Commission for the *Monument to Claude Lorrain* in Nancy. Official commission for a *Monument to Victor Hugo* in the Pantheon. Inauguration of the *Bastien-Lepage Monument* in Damvillers. Participates in the foundation of the Société Nationale des Beaux-Arts. *The Eternal Idol*.
**1890**  Commission for a bust of Puvis de Chavannes. Exhibits at the Salon of the Société Nationale. Travels in Touraine. *Despair*.
**1891**  Commission for a *Monument to Balzac* by the Société des Gens de Lettres. Trip to the Channel Islands. Medallion of César Franck.
**1892**  Inauguration of the *Claude Lorrain Monument*, which stirs controversy. Appointed Officer of the Légion d'Honneur.
**1893**  Exhibits at the Salon of the Société Nationale, in Chicago, and in Munich. Bourdelle joins his studio as assistant. Moves to Bellevue, in Meudon. Project for the *Tower of Labour*.
**1894**  Controversy over the *Balzac*. Travels in France.
**1895**  Inauguration of the *Burghers of Calais*. Commission for the *Monument to Sarmiento* in Buenos-Aires. Purchases the Villa des Brillants in Meudon.
**1897**  Salon: the unfinished *Victor Hugo*; publication of *The Drawings of Rodin* by Goupil, with preface by Octave Mirbeau.
**1898**  Salon: *Balzac* and *The Kiss* (enlarged). The contract for the *Balzac*

is cancelled. Subscription campaign organized by friends. Final break with Camille Claudel.

**1899** Exhibitions in Amsterdam, The Hague, and Brussels. Commission for a *Monument to Puvis de Chavannes*. Bust of Falguière, Eve.

**1900** 1 June, the Minister for Public Education, Georges Leygues, inaugurates the Rodin Pavilion at the Alma intersection for the Exposition Universelle. Lectures on Rodin (Mauclair, Morice, Picard). The Pavilion is re-installed in Meudon. Exhibits drawings in London. Opens a school with Bourdelle and Desbois. Inauguration of the *Sarmiento Monument*, which raises protests.

**1902** Trip to and exhibition in Prague. Banquet in his honour in London. Sojourn in Ardenza, at the home of Miss von Hindenburg. Rilke arrives. Posthumous inauguration of Falguière's *Balzac*. Illustrations for Mirbeau's *Jardin des supplices*.

**1903** Appointed Commander of the Légion d'Honneur. Exhibition in New York of works from the Loïe Fuller collection. Trip to London; commission for a *Monument to Whistler*, whom he succeeds as president of the International Society of Painters, Sculptors and Engravers. Busts of George Wyndham, Mrs Potter-Palmer, *The Athlete*.

**1904** Exhibits *The Thinker* (enlarged). Presents works in London, Saint Louis, Weimar, and Düsseldorf. Affair with the Duchess of Choiseul.

**1905** Exhibition in Boston. Awarded an honorary doctorate at the University of Jena.

**1906** Inauguration of The Thinker in front of the Pantheon. Exhibits in Ostende. Trip to Spain with Zuloaga. Inauguration of the *Monument to Maurice Rollinat*. Busts of George Bernard Shaw and Anna de Noailles. Follows the Cambodian dance troupe. Awarded an honorary doctorate at the University of Glasgow.

**1907** Honorary doctorate at the University of Oxford. Exhibits at Bernheim Jeune.

**1908** Exhibition of drawings at the Devambez Gallery, in Vienna, and in New York. Establishes a studio in the Hôtel de Biron. King Edward VII visits Rodin in Meudon. *The Cathedral*, busts of Hanako.

**1909**  Inauguration of the *Victor Hugo* in the gardens of the Palais-Royal. *Prayer*.

**1910**  Named Grand Officer of the Légion d'Honneur. Purchase of several sculptures by the Museum of Metropolitan Art in New York.

**1911**  The State acquires the Hôtel de Biron; Rodin's donation of his work permits the foundation of the Musée Rodin. Bust of Clemenceau. The British government buys a copy of *The Burghers of Calais*.

**1912**  Exhibition at the Metropolitan Museum of Art in New York. Travels to Italy. Drawings of Nijinsky. Break with the Duchess of Choiseul. First attack of paralysis. Model for the *Monument to Eugène Carrière*.

**1913**  Exhibits at the Armory Show in New York

**1914**  Exhibits in and travels to London and Italy. Publication of *The Cathedrals of France*.

**1915**  Stays in Italy to execute the bust of Pope Benedict XV.

**1916**  13 September, deed of donation to the French State. The Assemblée Nationale votes for the creation of the Musée Rodin. Bust of Minister Clémentel.

**1917**  29 January, weds Rose Beuret. 14 February, Rose dies. 18 November, death of Rodin.

# PHOTOGRAFIC CREDITS

**Akg Paris :** cover, p. 99, 151
**D. Bernard :** p. 153
**C. Bonnard :** p. 133
**Photos Bulloz :** p. 86
**Choumoff :** p. 230-231
**Harry C. Ellis :** p. 140
**Hutin :** p. 96-97
**Bruno Jarret :** p. 15, 19, 23, 24, 26, 30, 32-33, 37, 39, 43, 44, 47, 51, 53, 55, 59, 60, 61, 65, 67, 68h, 70, 76, 78, 80, 85, 89h, 90, 93, 95, 101, 106, 108-109, 111, 114, 118-119, 126, 127, 129, 132, 134-135, 137, 145, 147, 155, 158, 160, 165, 168, 169, 176, 190, 197, 199, 201, 204, 205-207, 210, 214-215, 217, 225

**Luc and Lala Joubert :** p. 183
**H. Lacheroy :** p. 184
**Adam Rzepka :** p. 8, 11, 20-21, 49, 68b, 71, 73, 75, 89b, 91, 103, 121, 122, 130, 156-157, 167, 170, 173, 185, 211, 226-227
**E. Steichen :** p. 174-175
**Dagli Orti :** p. 79

Nearly all of the reproductions of Rodin's work in this book were drawn from the Photo Library of the Musée Rodin in Paris.

*Printed by Groupe Horizon, France,*
*June 2006*